SECRET
NORTHALLERTON

Andrew Graham Stables

AMBERLEY

Acknowledgements

Thanks to my family, the publishers and the good people of Northallerton who made every visit to the town a pleasure.

First published 2020

Amberley Publishing
The Hill, Stroud
Gloucestershire, GL5 4EP

www.amberley-books.com

Copyright © Andrew Graham Stables, 2020

The right of Andrew Graham Stables to be identified as the Author of this work has been asserted in accordance with the Copyrights, Designs and Patents Act 1988.

ISBN 978 1 4456 9696 6 (print)
ISBN 978 1 4456 9697 3 (ebook)

British Library Cataloguing in Publication Data.
A catalogue record for this book is available from the British Library.

Origination by Amberley Publishing.
Printed in Great Britain.

Contents

Introduction

A *Gazetteer* from 1823 describes Northallerton as 'a brisk market town, pleasantly situated on the side of rising ground, gently sloping towards the east. The marketplace is spacious and surrounded with very good houses: the town is, in general, well-built of brick. The market is held on Wednesday, and there are four fairs.' Today Northallerton remains a small market town situated on low-lying ground to the northern edge of North Yorkshire, but this is a very simplistic description of a town that has an incredibly long and important history. Although it is known William I, the Norman Conqueror, chose to camp his army here in 1068, it was the powerful bishops of Durham who made the town an important ecclesiastical administration centre and built a residence to take full advantage of the town's location on the main route between Durham and York.

There is possible evidence of a Roman settlement here, a castle site built by Bishop Hugh Pudsey and a twelfth-century church built on the site of a much earlier building going back to the early days of Christianity. There was also a bishop's fortified house, known as 'the Palace', and this building was a place known for its hospitality, accommodating such important visitors as King John, Henry III and Edward I, who made it his customary

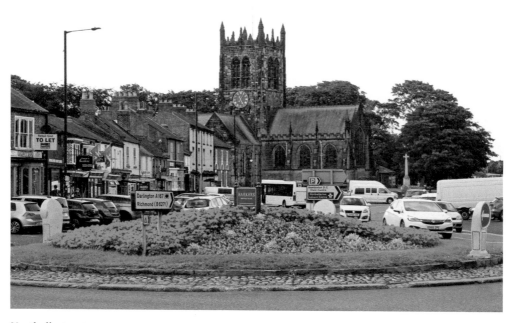

Northallerton town centre.

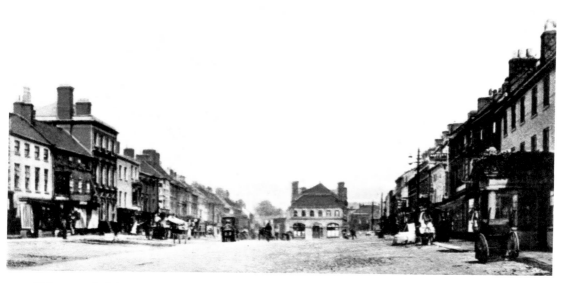

Old postcard of the town centre.

stopping place when on his way to Scotland. Edward II rested here in 1312 and Edward III stayed numerous times after founding a Carmelite friary here. The palace is long gone and the stone robbed to build other local houses, though 'a great piece of the gate' was said to have been standing in 1789. The remaining stone must be a substantial make up of many of the properties in the area to this day.

However, as a key town on a route north and south, Northallerton suffered over the years from the rebellious barons or invaders like the Scots, and it was very close to the town that the English forces assembled in 1138 for the Battle of the Standard – a significant clash of arms in the long-running conflict with the Scots. Later in the Civil War, the town would play an important role in the trade of a king determined to maintain royal power and his belief in the divine right of kings.

This book will explore some of the sites of the early history of the town and how this affects the layout of it today. It will reveal evidence of these early buildings in the landscape of the town and some of the important characters from history who make up the story of this historic town. It will also explore heroes of later conflicts in our history and explain how Northallerton, for one day, became the centre of a musical revolution.

DID YOU KNOW?
At a parish meeting in 1895 there were protests at how much public money was being spent on the new county council offices in Northallerton.

South side of Main Street.

Barkers, Main Street.

1. Early Beginnings

Surrounded by good farmland, it is likely the ancient peoples from the Bronze and Iron Ages would have occupied land in the area, especially slightly raised land near a good water source. Some evidence has been found nearby to suggest these peoples lived in or near the town. A bronze spearhead was found to the west of Castle Hills, and on the Solberge estate to the south a basalt stone axe was discovered. A bronze axe was found at Romanby, and a crop mark of a possible round barrow at Yafforth is further evidence of this area's early habitation. The Castle Hills area is generally thought to have Roman origins with possible later Norman workings; however, during my research of a number of market towns in the north, similar patterns arise, and the Castle Hill positioning and morphology suggests an Iron Age fortification. This is simply conjecture on my part, and sometimes I look at the human geography or the basic needs of people rather than history to explain the past.

In the Domesday Book the town is called Alvertune, Aluertune, and Alreton. Symeon (or Simon) of Durham, who was an English chronicler and monk of Durham Priory, wrote in the 1100s and called it Alvertona; however, Peter de Langtoft, an Augustinian canon from Bridlington Priory who wrote a history of England in Anglo-Norman verse, called it Alverton. Some believed that it took its name from the great King Alfred and was originally called Alveredtune, which was later softened into Alvertun, and Allerton.

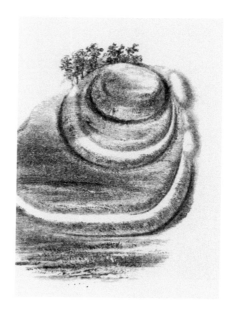

Sketch from 1794 showing the extent of the earthworks at Castle Hills.

Farmland at Yafforth, outside Northallerton.

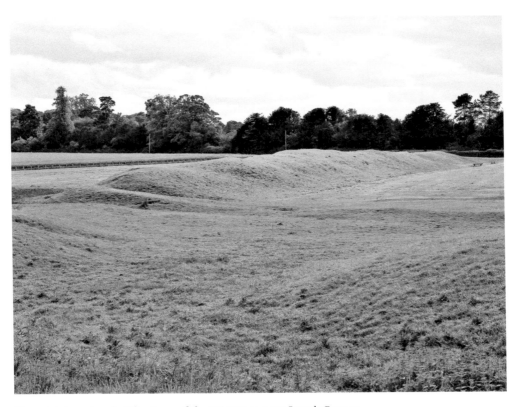

Stanwick Iron Age fortifications of the Brigantes, near Scotch Corner.

The addition of 'North' was added around 600 years ago, likely due to other towns named Allerton further south on or near the Great North Road.

Many consider the town to be quite ancient. It seems to have been a Saxon borough and may have been of Roman origin, possibly for its proximity to the Roman road north (now the A1). The suspected link being a route from the Catterick Fort over to Romanby and via York in the opposite direction. It is also thought that Paulinus, the missionary bishop famous for having baptised thousands in the River Swale, built a church at 'North Allerton' around AD 630. The dedication to All Saints favours a Saxon origin, but the restoration of the church in 1883–84 brought to light a quantity of crosses and stones of undoubted Saxon work, adding further evidence of its origins. The early and simple church was replaced by another in the Norman era, built probably soon after the manor came into the possession of the bishops of Durham.

When William the Conqueror was established on the throne he treated England as a conquered country, and following rebellions in the north of the country he began a more tyrannical reign. Much of the north was devastated during the Harrying of the North, where lands were burned and spoilt; people were not only killed, but many starved to

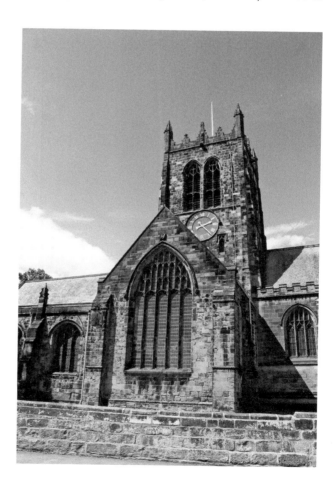

All Saints' Parish Church, Northallerton.

All Saints' Parish
Church, Northallerton.

death or died homeless in the winter. He formed many simple motte-and-bailey castles and installed nobles to guard over the populous. It is thought that the earthworks at Castle Hills may have originally been one of his bases. William established prohibitive rules with severe penalties, including the use of fire or candles, or when the curfew bell should ring in order to prevent any gatherings and plots. The custom of ringing the eight o'clock, or curfew bell, was a part of life in Northallerton for many years. The church has eight bells in the tower. Two were added to the existing six in 1871, but one is supposed to have belonged to the nearby Mount Grace Priory and is known as the Curfew Bell. Another, called the Shriving Bell, is believed to be of an older date.

Castle Hills and Bishops' Palace

The Castle Hills and bishops' palace fortification is divided by the (North East) Stockton rail line and the entire complex shows different eras of construction. As mentioned earlier, it is possible the original fortification was an ancient British hill fort, providing a strategic viewpoint of the area. But equally it may have been used by the Romans as a station to oversee two major Roman roads: one from York to Catterick, and the other from York to the Tees via Thornton-le-Street. There have been numerous finds on the site,

including Roman coins and some pottery, and located nearby a Roman altar was found dedicated to the 6th Legion.

Castle Hills had high embankments and deep ditches, which were much reduced in the nineteenth century and can only be seen as they may have originally looked on the west side close to the railway.

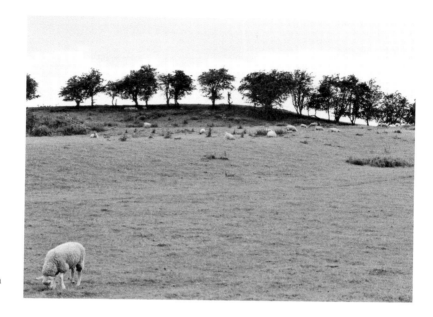

Castle Hills looking up from the east.

Castle Hills looking from the north.

The whole site is not easily deciphered due to so much activity at different periods of time. Part of the site contains evidence of a motte-and-bailey possibly founded by William the Conqueror when he positioned his forces at Northallerton in 1068–69 during his struggles to subdue the north of the country. The monument is an earthwork mound around 20 metres across and 60 metres across at its base, but part of the site has been destroyed by a railway cutting constructed in 1838. On the northern side of the motte the original encircling ditch has been modified to surround the later bishops' palace, and to the south-west of the motte there are the remains of a low earthen bank and ditch extending south-west. The site would have originally been protected by its situation at the junction of two streams: Willow Beck to the west and Sun Beck to the south and south-east. When it was built this would have been a wet and boggy area and would have added to the defensive attributes of the southern approaches to the stronghold. The site is of further historical interest by a later construction of a fortified palace for the bishops of Durham and, later in the nineteenth century, when the land was taken over to become a civil cemetery.

The first record of the castle at Northallerton is in 1130 when Bishop Rufus built a residence – considered to have been the motte and bailey. In 1141, Northallerton Castle is recorded as being captured by William Cumin as part of his attempt to become Bishop of Durham. He rebuilt or greatly modified the castle, but it was surrendered sometime after 1143. Records say further work was carried out by Bishop Pudsey in 1174, but on the orders of Henry II the castle

Castle Hills from the bottom of the hill.

Clear earthworks associated with the bishop's palace.

was destroyed in 1176 as part of his strategy to remove fortifications not approved by the Crown. The castle bailey was located to the town side of the motte. The bailey defences were heavily modified during the construction of the bishops' palace in the late twelfth century, and consequently the size and form of the original castle bailey is unknown. The surviving modified bailey survives as a ditch or moat up to 12 metres wide and 1 metre deep, which encloses a raised irregular-shaped area measuring a maximum of 140 metres north-west to south-east by 90 metres north-east to south-west. The moat encloses all but the northern side of the interior. It originally extended across the northern side, but was infilled in the 1940s when the current cemetery, located to the north of the monument, was established. There was an entrance through the moat (15 metres wide) on the north-eastern side, which still survives as the main access into the centre of the old cemetery. There is a reference to a stone-built gatehouse, but it is unclear whether this was located inside or outside the moat. Outside the moat, on the western side, there is a flat-topped bank 8 metres wide with a narrow ditch on each side, which extends from the motte as far as the northern angle of the moat. It is thought to be the remains of a formal promenade dating to the time of the bishops' palace. There is no evidence that there was a similar bank on the other sides of the moat. Immediately inside the ditch the ground rises to be approximately 2 metres above the ground level on the outside of the ditch. It is thought that this was originally an internal bank for the defences of the bishops' palace; however, the extent of this has been obscured by later modifications, mostly dating to the nineteenth-century landscaping associated with the cemetery.

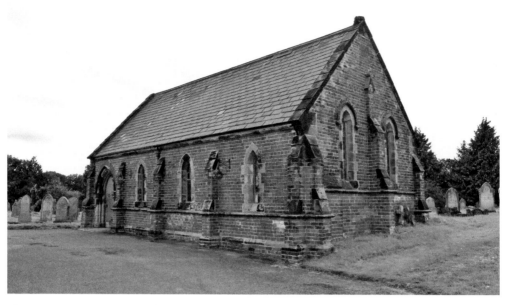

The cemetery now occupies the site of the palace.

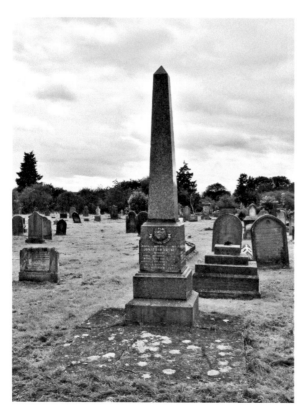

Cemetery headstones.

The destruction of the original castle led to a total renovation of the whole site with the bishops' palace being built in the style of a fortified and moated residence. The whole complex was surrounded by a defensive moat, much of which is still evident today. Leland, the traveller writing between 1535 and 1543, mentions 'the ditches and the dungeon hill where the castelle of Alverton sumtime stode.' In 1838 when the railway was under construction and cutting through the site it is mentioned that it 'consisted of a circular mound in the centre, and high embankments below at some distance, with deep trenches and ditches, altogether occupying an area of at least 20 acres'.

To guard against the Scottish raids, there is a reference in the early fourteenth century to a pele tower being built at the palace on the orders of Edward I, who was a regular visitor to the palace. It is also recorded that his army assembled at Northallerton before heading north to the Battle of Falkirk in 1298, which ended in the defeat of William Wallace. Following the victories of Robert the Bruce at Bannockburn and the weak leadership of Edward II, however, the town was ransacked and the church burned in 1317.

The palace was an important centre for the administration of the bishops' lands in Yorkshire and served as one of the major residences for the bishops and their staff. By having an obvious presence in the town the bishops were able to protect and consolidate their position in the area, particularly against the rivalry of the Archbishop of York. Part of the significance of Northallerton for the bishops was that it lay on the main road from York to Durham and was a regular stopping place for royalty and other dignitaries. It is reported that Edward I stayed with his royal retinue at the palace on six occasions between 1291 and 1304 on his way to and from Scotland. In the early sixteenth century, Princess Margaret Tudor, the future wife of King James IV of Scotland, stopped at the palace, accompanied by 1,500 men.

As well as being lords of the manor with the dues and entitlements that came with it, the bishops had an impact on other aspects of medieval Northallerton. They founded St James Hospital in c. 1200, gifted an endowment to the new Carmelite friary in 1356 and were patrons of the Grammar School in 1385. The active involvement of the bishops in Northallerton started to go into decline during the religious upheavals of the sixteenth century and the Dissolution of the Monasteries. The palace was described by Leland in 1538 as 'strong and well moated' but by the following century it was certainly neglected. In 1663 Bishop Cosins ordered that stones from the palace be taken and used to repair the castle mill and parts of the marketplace. By the end of the seventeenth century the palace was in ruins and was being used as a quarry for other buildings in the town. An undated print, thought to be of mid-eighteenth century in date, shows the palace in a ruined state and a map of 1797 shows no structures left on the site. In 1836, the authority of the bishops of Durham as landlords ended and the property passed to the diocese of Ripon. The area of the castle occupied by the old palace was sold to the parish in 1856 and was used as a cemetery.

Within the interior, the ground has been levelled up to create a platform standing up to 3.5 metres above the ground level outside the moat, which is the focus of the cemetery. In this area there is a regular pattern of paths dividing the cemetery into blocks. There is also a pair of matching mortuary chapels standing either side of the entranceway.

In common with similar ecclesiastical and lay residences, the bishops' palace would have been at the centre of a large enclosure known as the precinct. The boundaries of the

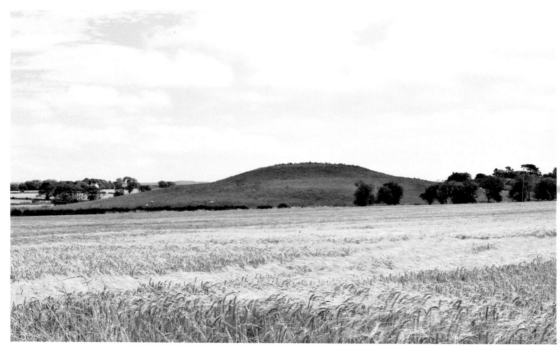

Howe Hill, near Yafforth.

precinct are easily identified on old maps and is still obvious from the current street plan. Such a high-status building would be of a very high standard and abound with elaborate architectural details, all intended to impress and to reflect the power and prestige of the owner. One consequence is that the approach would have been carefully managed to underscore the status and to ensure any visitors were suitably impressed. The entrance to the palace was on the north eastern side and is orientated towards the old marketplace and parish church. This area would have originally been the hub of the medieval town – the centre of commerce and religious instruction. The layout of the medieval marketplace guided the visitor into a narrow entrance that opened onto a view of the entrance and the façade of the palace. This impression is shown on the street and field plan of many of the old maps and is still well preserved in the modern street plan where the wider precinct is preserved as open space.

Apart from the moat, there are no remains of the bishops' palace, and the site is covered by a modern cemetery.

Howe Hill – Yafforth

North-east of Yafforth, in a low-lying meadow by the River Wiske, is the earthwork remains of a motte castle known as Howe Hill. A motte is an earthen mound, sometimes built on a natural feature or even filled with stones, then surrounded by a ditch. Built on the top would have been a stone or wooden structure with a palisade or wall and a further fence or wall at the lower ditch. Howe Hill is a flat-topped mound around

65metres (213 feet) in diameter at the base and 25 metres (82 feet) at the top. The mound is around 4.5 metres high and is surrounded by a ditch with a possible outer bank at the perimeter. The earthworks are much diminished, with some parts filled in and a possible entrance visible at the north side. It is believed Howe Hill was built during the reign of King Stephen (1135–54), a time of civil war between Matilda (Henry I's daughter and rightful heir to the throne) and Stephen (her cousin, who seized the Crown upon hearing the news of the king's demise) – a period known as the Anarchy. This political unrest led barons to erect 'adulterine' fortifications without permission of the king and would garrison troops to protect their lands or to maintain order. The site was referred to as the 'Castle of Yafforth' in 1197–98 as standing in the pasture of the isle of Yafforth. The builder is suspected of being a member of the Brettevill or De la Mare family, but no records survive to confirm this.

On the wall of a house lying to the west of the road leading to the church is a shield of arms, showing a sleeve quartered with a chevron between three boars. This fortification would have protected the crossing of the River Wiske by the old High Road (B6271) from Northallerton to Catterick and on to Richmond. The castle was probably suppressed during the reign of Henry II (1154–89), who was the son of Matilda.

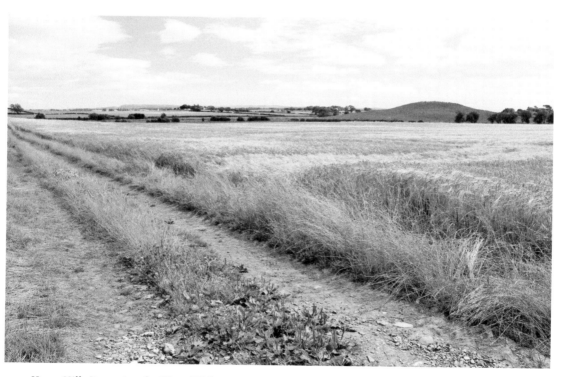

Howe Hill sits next to the River Wiske.

2. The Bishops of Durham

The bishops of Durham were also known as the 'Prince Bishops' due to the extensive power the appointed bishop held within their County Palatine, and because these powers were sanctioned by the new Norman overlords, they could be called kings of the north. The bishops of Durham had the power to hold their own parliament, raise their own armies, appoint their own sheriffs and justices, administer their own laws, levy taxes and customs duties, create fairs and markets, issue charters, salvage shipwrecks, collect revenue from mines, control the forests and mint their own coins. They ruled like a northern king and resided in their castles or palaces at Durham City, Bishop Auckland and Northallerton. The lands ruled by the bishops were seen as a defensive buffer zone between England and the Northumbria-Scottish borderland due to the lawlessness of this region.

The bishops of Durham held property throughout the north-east, including Yorkshire, some of which dated back to pre-Conquest days. Following the Conquest in 1066, the manor of Northallerton was granted by William II to William de St Carileph, Bishop Of Durham between 1087 and 1100. The first record of the castle at Northallerton is mentioned in 1130 when Bishop Rufus built a residence, a fortified residence in the form of a motte and bailey. This defensive structure would be a base, installed with a steward, who would be expected to administer and protect property as well as the assets held in the area.

The controversial Bishop Cumin was responsible for a major rebuild or significant enlargement to the residence. Cumin was a bishop who usurped the position of Prince Bishop of Durham with encouragement from King David of Scotland who had been beaten at the Battle of the Standard only three years earlier. Cumin used his own band of armed enforcers and fighting men to terrorise and threaten the inhabitants of the bishopric estates, but his actions did not go unnoticed and William De St Barbara was elected as the true Bishop Of Durham. William De St Barbara headed north supported by local barons, including Roger Conyers (who had vast lands in North Yorkshire), to remove Cumin. However, Cumin would not stand down and, after a skirmish, William was forced to retreat from Durham. William De St Barbara determined to try again, enlisting the help of the Earl of Northumberland, and in August 1144 was successful. Cumin was later captured by Roger Conyers at Kirk Merrington and relinquished his claims to the bishopric.

The motte-and-bailey castle may have been further improved by Bishop Puiset, or Pudsey, but during the reign of Henry II any threats or 'adulterine' castles were ordered to be destroyed. A contemporary writer mentions in 1177 the destruction of a 'castellum novum de Alverton – a new castle of Northallerton.

After the turmoil of this period a more substantial fortified palace was built to replace the old motte and bailey, but within the area of the former bailey, which was modified to suit. The outer moat was extended and recut to encompass these improvements. The end result was a palace similar to a type of structure popular in England at this time known as a moated site and generally used for high-status residences – less defensive and much more a statement of prestige.

This palace would have been a more comfortable residence than the old castle. It is known to have been used by the Archbishop of Canterbury – certainly in 1199 when he stayed there as a guest of the Bishop of Durham. As with most high-status buildings in the country there would have been an ongoing refurbishment and modernisation, often reflecting the latest architectural fashion. Work was undertaken at the palace in 1226, 1292 and 1309, some of which may have been prior to the visits from dignitaries and rulers of the realm. Guests to the palace also include King John, Edward I on numerous occasions, Edward II and Edward III.

There is a reference in the early fourteenth century to a pele tower being built at the palace on the orders of Edward I at a time when there was a general fortification of towns in the north to guard against raids from the Scots. Despite this, in 1317, at a time when the town was ransacked by the Scots, the palace was successfully attacked by Sir Gosselin Denville.

The palace was an important centre for the administration of the bishops' lands in Yorkshire and served as one of the major residences for the bishops and their staff. By having an obvious presence in the town, the bishops were able to protect and consolidate their position in the area, particularly against the rivalry of the Archbishop of York. Part of the significance of Northallerton for the bishops was that it lay on the main road from York to Durham and was a regular stopping place for royalty and other dignitaries. It is reported that Edward I stayed with his royal retinue at the palace on six occasions between 1291 and 1304 on his way to and from Scotland. In the early sixteenth century, Princess Margaret Tudor, the future wife of James IV of Scotland, stopped at the palace accompanied by 1,500 men.

As well as being lords of the manor with the dues and entitlements therewith, the bishops had an impact on other aspects of medieval Northallerton. They founded St James Hospital in c. 1200, gifted an endowment to the new Carmelite friary in 1356 and were patrons of the Grammar School in 1385. The active involvement of the bishops in Northallerton started to go into decline during the religious upheavals of the sixteenth century. It was described by Leland in 1505 that the palace was 'strong and well moated'. In 1539 the palace was still standing, but by the following century had become neglected. In 1663 Bishop Cosins ordered that stones from the palace be taken and used to repair the Castle Mill and parts of the marketplace. By the end of the seventeenth century the palace was in ruins and was being used as a quarry. An undated print, thought to be mid-eighteenth century in date, shows the palace in a thoroughly ruined state and a map of 1797 shows no structures on the site. In 1836 the jurisdiction of the bishops of Durham as landlords ended and the property passed to the diocese of Ripon. The area of the castle

The immense and important Durham Cathedral.

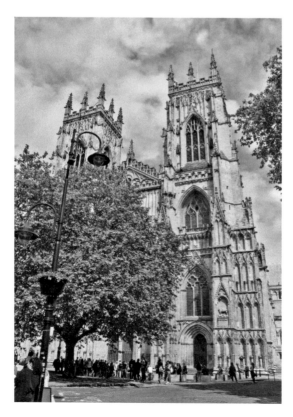

York Minster, second only to the see of Canterbury.

occupied by the bishops' palace was sold to the parish in 1856 and landscaped for use as a civil cemetery, which was in operation until the late 1940s.

DID YOU KNOW?
The term 'raising the standard' entered the English language because of the Thurstan standard at the battle held near Northallerton.

What follows is a list of the bishops of Durham from the time the palace is thought to have been built until the Reformation and the considered end of the bishop's interest in Northallerton:

Geoffrey Rufus (1133–40) – credited with the building of a residence on the site
William Cumin (1141–43)
William of St Barbara (1143–53)
Hugh de Puiset (1153–95)
Philip of Poitou (1197–1208)
Richard Poore (1209–13) – his election was supressed by Pope Innocent III as part of his quarrel with King John but he was later elected and consecrated
John de Gray (1214) – unfortunately he died before consecration after further wrangling with the pope
Morgan (1215) – Election quashed
Richard Marsh (1217–26)
William Scot (1226–27) – Election quashed
Richard Poore (1229–37) – Translated from Salisbury
Thomas de Melsonby (1237–40) – Resigned before consecration
Nicholas Farnham (1241–49)
Walter of Kirkham (1249–60)
Robert Stitchill (1260–74)
Robert of Holy Island (1274–83)
Antony Bek (1284–1310) – only English bishop to hold the post of Titular Patriarch of Jerusalem (1306–11)
Richard Kellaw (1311–16)
Lewis de Beaumont (1317–33)
Richard de Bury (1333–45)
Thomas Hatfield (1345–81)
John Fordham (1382–88) – Translated to Ely
Walter Skirlaw (1388–1406) – Translated from Bath and Wells
Thomas Langley (1406–37)
Robert Neville (1437–57) – Born at Raby Castle, Staindrop, County Durham and son of Ralph de Neville, 1st Earl of Westmorland, and Joan Beaufort

Lawrence Booth (1457–76) – Translated to York
William Dudley (1476–83)
John Sherwood (1484–94)
Richard Foxe (1494–1501) – Translated from Bath and Wells. Later translated to Winchester
William Senhouse (1502–05) – Translated from Carlisle
Christopher Bainbridge (1507–08) – Translated to York
Thomas Ruthall (1509–23)
Thomas Wolsey (1523–29) – Archbishop of York but also held Durham in commendam
 (meaning he held the post until a suitable candidate could be found)
Cuthbert Tunstall (1530–59) – Translated from London. Reformation during his tenure

DID YOU KNOW?
John Craddock, vicar of Northallerton, who died in 1627, was rumoured to have
been poisoned by his wife. She was accused, tried and acquitted.

3. Battle of the Standard

At dawn on Monday 22 August 1138, on Cowton Moor, 3 miles north of Northallerton, the armies of Archbishop Thurstan of York and King David of Scotland faced each other. The open wide moor edged by blooming heather and shrouded in a ground mist was about to become host to the most significant battle against Scottish aggression during the turbulent reign of King Stephen (1135–54).

The political beginnings of the conflict lie in the succession of the English throne and between Matilda, daughter of Henry I, whom he wanted to succeed, and Henry's nephew Stephen, who was favoured by the Norman barons. Stephen was crowned on 26 December 1135, in Matilda's absence, with the support of the Archbishop of Canterbury and the pope. Some factions did not support Stephen, including her uncle, David I of Scotland; he saw this unrest as a chance to take Northumberland for his allegiance to Matilda. At the end of 1135 David marched south taking Carlisle, Alnwick and Newcastle as well as other key towns in the north. Stephen quickly marched north at the head of an army and met David at Durham, where in February 1136 the Treaty of Durham was agreed.

Stephen had to deal with further insurrections, but his most serious came in 1138 when Matilda's half-brother, Robert of Gloucester, rebelled against Stephen, starting the descent into civil war in England. Taking full advantage of this further unrest was David I of Scotland, who in March 1138 crossed the Tweed with a 'motley army' consisting of Normans, Germans and Cumbrians, supplemented by Northumbrians, Lothians and Picts – called the men of Galloway. They proceeded south with 'great savagery and atrocities' carried out on the populous, where villages and churches were burnt to the ground. The people of Northumbria and Durham were subjected to an onslaught of barbarity according to the chroniclers, with many massacred regardless of age or gender. Repeatedly, historians of the time refer to King David as a humane man 'often moved to tears of compassion in consequence', but he failed to control the cruelty of his soldiers and they greatly angered the English. This anger would lead to great resolve and feelings of revenge as the English were mobilised against them.

King Stephen was occupied in the south of the country with Robert of Gloucester's rebellion and ordered Thurstan, Archbishop of York, to raise an army to halt the advances of the Scottish.

Thurstan was of some age, believed to have been born *c.* 1070, so at the time of the battle would have been around sixty-eight. He was not well at the time and did not attend the battlefield on the day, having to remain in Thirsk. Stephen also despatched Bernard de Baliol to the north to support the eminent northern barons under Thurstan, including Robert de Brus, Walter de Gaunt, Earl of Albemarle, Alan Percy, Walter d'Espec William

de Percy, Robert de Stuteville, Gilbert de Lacy, Ilbert de Lacy, Eustace Fitz-John and Ralph Nowell, the titular Bishop of Orkney representing Thurstan.

Thurstan created the holy standard to encourage the feeling of religious fervour and sense of a higher cause. The standard consisted of a spar or mast from the convent at Beverley, mounted on a four-wheeled cart, finished off with a large crucifix, a silver box containing the sacraments and hung with the banners of the sainted Peter of York, Wilfred of Ripon, Cuthbert of Durham and John of Beverley. Hugo de Sotevagina, Archdeacon of York inscribed a rhyme on the base of the mast:

> Dicitur a stando standardum quod stitit illic
> Militae probitas vincere sive morri
>
> (Standard, from stand, this fight we aptly call
> Our men here stood to conquer or to fall)

A number of the barons were in a peculiar dilemma, as they held lands and estates in Northumbria where David was their liege lord, but also held estates in England and Normandy under Stephen. From Thirsk, where the English army was based, they sent Robert de Brus, Earl of Annandale and Bernard de Baliol to offer terms to David. If David would withdraw and return to Northumberland in peace, they would secure from Stephen a grant of the earldom of Northumberland. David refused and remained loyal to the cause of Matilda. The two noblemen had to renounce their allegiance to the Scottish Crown and rejoin the English army in great haste.

The English moved forward to take up position north of the town to await the Scots. The battlefield is on the Northallerton to Darlington road (now designated the A167), in the fields of Standard Hill Farm and it was here where the English formed up around the standard. The English record great speeches from Robert de Brus, Walter d'Espec and Ralph, Bishop of Orkney. Robert de Brus spoke of his friendship with King David and his desire for him to leave the field of battle and, though the Scots were more numerous, he said, 'The English were more valiant and strong, and resolved to conquer or lose their lives.'

Walter d'Espec was an old and experienced warrior who ascended a platform that had been constructed and encouraged the men by his spirited words: 'I pledge thee my troth to conquer or to die.' As he spoke these words he placed his gloveless hand in that of the Earl of York and the soldiers gripped each other's hands while repeating the words in a rallying cry. Finally, in Thurstan's stead, Ralph, Bishop of Orkney, 'standing on an eminence in the centre of the army', spoke with eloquence and inspired the army further:

> Brave nobles of England, Normans by birth; for it is well that on the eve of battle you should call to mind who you are, and from whom you are sprung: no one ever withstood you with success. Gallant France fell beneath your arms; fertile England you subdued;

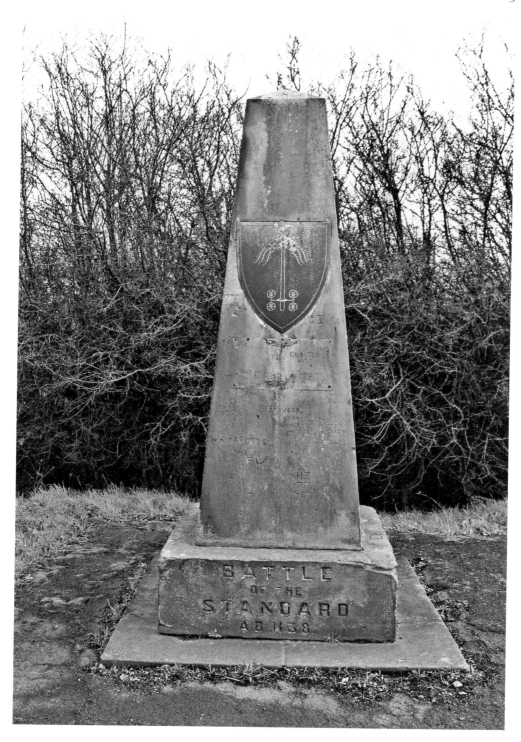

Memorial to the Battle of the Standard.

rich Apulia flourished again under your auspices; Jerusalem, renowned in story, and the noble Antioch, both submitted to you.

He then went on to tell how the Scots were no match for their military skill and organisation, and there was no need to fear the enemy when God was on the side of the English. Perhaps more of an advantage was his mention of the fact that 'they do not cover themselves with armour in war' and his observation that 'your head is covered with the helmet, your breast with a coat of mail, your legs with greaves, and your whole body with the shield. Where can the enemy strike you when he finds you sheathed in steel?' This state of dress may not have included the full English army, but the rank and file of the Scots used no defensive armour, most likely only wearing a kilt (a great kilt or full-length garment and partly worn as a cloak wrapped around shoulder or used as a hood). The English replied with a shout and a loud 'Amen!' At the same time the Scots could be heard with their own war cry and the scene was set for a brutal clash of steel on steel.

The Scots had disagreements about the disposition of the army and the bravery of the different factions. In the end David had to pacify the quarrel and ordered the Glaswegians to take the vanguard. The battle began very early in the morning, with the vanguard charging with such fury and reckless courage and armed only with swords or pikes. Their half-naked bodies were revealed by a lifting mist and the kilts working free in the charge, as they screamed 'Albanigh! Albanigh!' (or 'the men of Albany!). The English responded with scorn, shouting 'Eyrych, Eyrych' (meaning 'you are but Irish') – Glaswegians were called the wild Scots of Galloway, who were descended from Irish settlers.

They were no match for the more heavily armed English men-at-arms, who were drawn up in a dense column around the standard. In front of them sat the yeomen from Yorkshire, Lincolnshire and Nottinghamshire, armed with bow and firing a hail of arrows into the attacking Scots. The records are not totally clear, but it seems the English archers broke under the onslaught of the charge and later rallied. King David's son, Prince Henry, attacked with cavalry and was driving the English mounted men back towards Northallerton, though one report says he achieved nothing apart from chasing a few grooms from the field. Post-battle bravado or not, at the same time a rumour spread that King David had been killed and the Scots began to lose heart. The story goes that as Prince Henry began to press home his attack, an English soldier hacked off a Scotsman's head, then held it aloft, loudly shouting 'behold the head of the King of the Scots!' To try and halt the panic, King David, without helmet, rode into the retreating forces in an attempt to rally the troops, but it was too late.

Though the battle lasted for around two hours and the Scots may have rallied again to attack the English, the weakened force could not break down the defenders of the standard and were chased from the field. The king and his retinue retreated to Carlisle and awaited their friends and sons, but the English pursued the remaining Scots and put to death all they could find. It is said between 10,000 to 12,000 were killed. Prince Henry managed to extricate himself and some followers from the fray and, though wounded, he managed to meet up with his father at Carlisle three days later. Just to the south of the

Battlefield area.

battlefield is Scots Pits Lane and suggests the location of the buried troops. In 1855, forty skeletons were uncovered at Kirkby Wiske Rectory and confirm the tales of many Scots being killed on the roads as they made for home. Gilbert de Lacy being the only English knight slain.

One of the combatants is of particular interest to me, as he is responsible for the foundation of my home town of Barnard Castle: Bernard de Baliol, the nephew of Guy de Baliol, originally from Bailleul in Normandy, who built the castle, then called Bernard Castle. After the Battle of the Standard, Bernard remained loyal to King Stephen and was taken prisoner with his royal master at the Battle of Lincoln.

Later, in 1174, when the Scots besieged Alnwick Castle, Bernard joined with the English barons on their march to its relief, at one point it was felt they should halt on account of a dense fog, but bravely said 'Let them stay that will, I am resolved to go on, though none follow me, rather than dishonour myself by staying here.' It was by this example, by continuing on, they managed to surprise the enemy and in a short but fierce skirmish called the Battle of Alnwick where they took the Scottish king prisoner and held him in Richmond Castle.

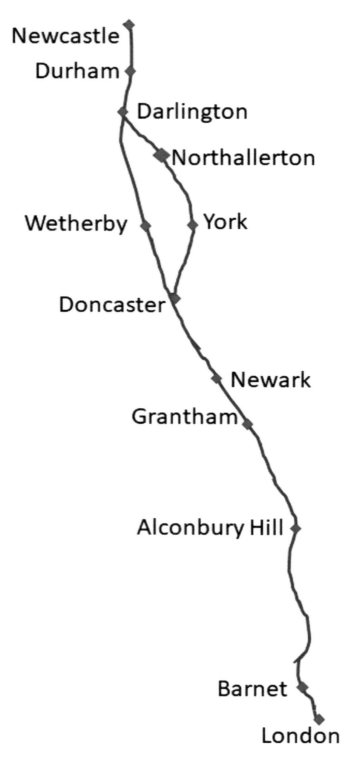

The route of the Great North Road.

Northallerton – A Rallying Point

Over the years Northallerton has been a rallying point – the place to meet before heading into battle or moving on to take on an enemy. We know William the Conqueror rested his forces here before advancing further north, and know the forces gathered here prior to the Battle of the Standard. Further examples include Edward I and his forces as he headed north to fight the Scots, Edward II for the same, but less successful purposes. During the Wars of the Roses followers of Mowbray and Archbishop Scrope are known to have assembled in Northallerton, and Henry IV stayed at the bishops' palace. Some of those involved in the Pilgrimage of Grace against the dissolution rallied at Northallerton, and a few years later men from Northallerton were executed for their part in the Rising of the North against Elizabeth I.

Charles I led a force against the rising of the Covenanters in Scotland in 1639 and he came to York, accompanied by the nobility and his officers. After staying for nearly a month in the city he proceeded with his army towards Scotland and as he did, the Scots submitted, laid down their arms, and swore obedience to their sovereign. That year the Scottish army invaded England and once again the king set out from London and arrived at York. He dined with the Lord Mayor of York and later rode on to Northallerton, when he was informed of the defeat of Sir Thomas Fairfax at Newburn and that the Scots had taken Newcastle, the King returned to York. However, the king's forces had rallied and concentrated at Northallerton. There is also correspondence in a letter to Lord Fairfax during 1648 confirming Oliver Cromwell stayed in or very near to Northallerton.

The last major conflict on British soil does not escape the Northallerton connection. During the 1745 Jacobite rebellion the English army, under movement of the command of William Augustus, Duke of Cumberland, the second son of George II (who was viscount Northallerton incidentally) passed on their way to the north and pitched their temporary camp at the Castle Hills. The army chased Bonnie Prince Charlie across the country with a skirmish at Clifton in Cumbria, and pursued the prince through Penrith and Carlisle, until finally defeating him at the Battle of Culloden.

4. People

The population of Northallerton and surrounding areas around the late 1700s is estimated at around 2000 people and by 1821 this had risen to over 3,000, but by 1881 this had risen to nearly 5,000. This was mainly due to better understanding of health and the introduction of the railways, which were well established by this date. Before the First World War the population had reached somewhere around 7,500 and prior to World War Two it had reached 8500. The population is now approaching 17000 (2011) and with the new housing developments it may have already overtaken this number. Throughout history many notable people have been born in Northallerton and its surrounding villages. Below are just a few of the people who may be of interest.

Roger de Mowbray

Roger de Mowbray was one of the most important local figures during the period 1129 to 1187. On his father's death in 1129 he became a ward of the Crown, but upon reaching his majority in 1138 he took title of his father's lands in Normandy – Thirsk Castle (where he was based) and various estates throughout Yorkshire and Lincolnshire including Kirkby Malzeard, Craike, Henderskelfe and Kinardferry. He also participated in the Battle of the Standard in 1138 and, according to the sources, fought admirably. During the reign of Stephen and the Anarchy, de Mowbray was captured by the forces of Empress Matilda

Coat of arms of de Mowbray.

View of the Vale of Mowbray.

at the Battle of Lincoln in 1141. Following his release from captivity he married Alice de Gant and had two sons as well as a daughter before joining a group of English nobles with Louis VII of France on the Second Crusade and gaining further acclaim.

Henry II, father of Prince Henry, Richard the Lionheart and King John, had a turbulent rule between 1154 and 1189. In addition to England, he ruled lands in Wales, half of Ireland and huge swathes of land in what we now call France. He is also well known for his desire to reform the Church and for his conflict with Thomas Becket, Archbishop of Canterbury, ending in the Bishop's murder. Throughout his reign he endured challenges to the throne, but none were more aggressive than from his sons who, as they grew older, demanded a greater share of power within his empire.

Roger de Mowbray supported Prince Henry in the revolt of 1173–74 against Henry II and fought with his family against the king. The prince had also promised William the Lion (King of the Scots) Northumbria and Cumberland in exchange for military assistance. The rebellion lasted for eighteen months, but on 12 July 1174, at the Battle of Alnwick, William the Lion was captured, though Roger de Mowbray escaped. Fearing that his castle at Thirsk would be attacked by the king's forces, he sent a message to his nephew to not surrender the castle.

The castle, expecting the forces of Mowbray, were warned of the king's forces heading from Easingwold after having razed the castles of Craike and Henderskelfe (which was

originally on the grounds of Castle Howard). No attempt was made on the castle that night, but in the morning the news came that Roger de Mowbray's troops were utterly defeated near Northallerton by a force that had marched from Barnard Castle. Roger escaped again, but later in 1174 was forced to make his 'personal submission and surrender of Thirsk Castle to King Henry II in Northampton'. His other castles at Kinardferry and Kirkby Malzeard had already been defeated and, though pardoned by the king, his castles were declared forfeit and destroyed by 1176.

Roger left for the Holy Land again in 1186, but encountered further misfortune by being captured at the infamous Battle of Hattin in 1187, where the Muslim armies under Saladin captured some of the senior crusaders. His ransom was met by the Templars, but he did not survive for long and is thought to be buried at Tyre in Palestine.

DID YOU KNOW?
It is thought the stone from Thirsk Castle was used in the construction of St Mary Magdalene Church in Thirsk.

Walter d'Espec (or Espec)

Walter d'Espec was one of the prime commanders at the Battle of the Standard, although this is the only battle in which he is referenced. We know his father was probably William Speche, a follower of William the Conqueror, and he built Helmsley and Wark castles. His lofty position and address to the soldiers at the Battle of the Standard shows him to have been a respected warlord and an experienced fighter. He founded and amply endowed the abbeys of Kirkham and Rievaulx. He had a son by his wife Adelina, also called Walter, but he was killed in a fall from his horse to the 'great grief of his father' who resolved to 'make Christ heir of part of his lands'.

Walter died in 1153 and was buried on 9 March in Rievaulx Abbey where two years before he became a monk. He left his possessions to his three sisters, one of which was married to Peter de Roos and took over the castle at Helmsley, and it was their son who built the grand stone castle now in the protection of English Heritage. Aelredus Rievall described Walter d'Espec as 'quick-witted, prudent in counsel, serious in peace, discrete in war, a trusty friend, a loyal subject, of stature more than ordinary large, yet comely; his hair black, his beard long, forehead high, great eyes, big face, but beautiful, shrill voice, in speech elegant, and of noble extraction, wanting issue of his body.'

Robert de Brus

Another son of a follower of William the Conqueror, Robert de Brus was the issue of Robert de Brus Sr and Agnes, daughter of Waltheg, Earl of St Clair. Robert II resided chiefly at the court of Henry I, where he enjoyed the confidence and friendship of David, Earl of Cumberland, who later became king of Scotland and on his accession to the throne, out of affection and gratitude, conferred upon him the lordship of Annandale

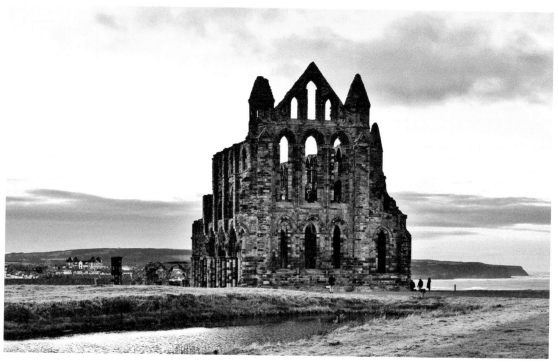

Whitby Abbey.

in Scotland. It was Robert de Brus who had spoken with David, before the Battle of the Standard to try and avoid the conflict.

Robert de Brus was responsible for the founding of Guisborough Priory and he gave the church of Middlesbrough to Whitby, as well as gifted his lordships of Appleton and Hornby to the abbey of St Mary, at York. He died in 1141, and was buried within Guisborough Priory, leaving two sons: Adam, who inherited the lordship of Skelton, and Robert became lord of Annandale in Scotland.

It was his descendants who became known as 'The Bruce' and lead the Scots to invade England including the burning of Northallerton.

King John

After a tour in the northern counties, King John and his entourage arrived at Northallerton on the Friday afternoon of 20 June 1212 and left the very next day for Easingwold. On Saturday 1 September in the same year, King John and his court were again at Northallerton, where they remained over Sunday, probably attending Mass at All Saints' Church before leaving on the Monday morning for Darlington. On the following Thursday the king and his retinue returned to Northallerton from Durham, and left the next day for Knaresborough. Further evidence of the importance of the Bishop of Durham's hospitality and what a crossroads Northallerton was for important people of the kingdom.

William Younge Jeeves

William Younge Jeeves was born in 1828 at Sharrow Grange, Sheffield, and qualified as a Member of the Royal College of Surgeons (MRCS) in 1852. He entered the Army Medical Department as an assistant surgeon on 7 April 1854, aged twenty-six years. He went on to have an illustrious military career and died at the age of forty-seven in Northallerton.

When the Crimean War began in 1854, the medical and logistical support was organised by civilian departments and was based on a peacetime arrangement of regimental hospitals. The medical officers were commissioned and wore regimental uniform but held no military rank and were under the command of the colonel of his regiment. There were no trained staff and they were simply allocated a number of ordinary soldiers from the regiment to assist. There was national outcry at news of the soldiers suffering from disease and depravations – some before they had even had chance to fight. The demand for medical staff and surgeons was addressed with great haste by those in charge of the war and it was in these circumstances that William entered service and was despatched with the 38th (1st Staffordshire) Regiment of Foot to the Crimea.

He served in the campaign of 1854–55 and was present at the Battles of Alma, Inkerman and the siege and fall of Sebastopol. He was mentioned in despatches and received the Crimea Medal (with three clasps) and the Turkish Medal. Major-General Eyre's despatch stated, 'Assistant Surgeon Jeeves of the 38th, whilst exposed to a most galling fire, having exerted himself in the field in attending to the wounded in so zealous and humane a manner as to call forth special notice.' More surprising is his award of the Légion d'Honneur 5th Class. The Legion of Honour was awarded to 746 members of the British

War memorial.

Armed Forces during the Crimean War and before this there was no precedent for the exchange of awards between allied nations. It was in January 1856 when Queen Victoria and the Emperor of France formally agreed to an interchange of decorations between their two armies.

By August 1856 he was appointed staff assistant surgeon and was on duty at Winchester with the 38th. In January 1857, William was appointed to the staff of the Royal Artillery and subsequently saw service with the 11th Brigade RA during the Indian Mutiny. He became surgeon in November 1864 and was appointed to the 2/25th (the King's Own Borderers) Regiment of Foot in 1865.

He also served in Ceylon (Sri Lanka), Malta and Honduras before returning to England on half-pay in 1872/73 not long before he died at Northallerton on 7 March 1875. His collection of medals and memorabilia recently sold at auction for £1,750.

Chief Constable Thomas Hill

Thomas Hill was born in 1822 at Thornton-le-Dale in Ryedale and died at Romanby on 5 November 1899; he is buried in Northallerton Cemetery. He was the son of Richard Hill, Justice of the Peace for Thornton-le-Dale. Thomas rose through the ranks to be a captain in the North Yorkshire Militia and was a considered a model soldier with his bearing, efficiency, energy and a meticulous attention to detail. He also displayed an 'organisational ability and practical creativity'.

The North Riding Constabulary was formed in 1856 as a result of the County and Borough Police Act of 1856. It covered all of the North Riding except for the boroughs of Middlesbrough, Richmond and Scarborough, all of which had their own borough constabularies. Thomas became the first chief constable of the North Riding Constabulary due to his skills as a captain of the North York Militia and initially consisted of the chief constable and just fifty men of all ranks. Before long Captain Hill had lost forty-eight of the fifty men; they did not like the training and could not cope with military-style drill of square bashing and the required discipline. They would not stop drinking in pubs, maintaining their old associations and they were considered incapable of discretion.

However, Chief Constable Hill managed to persuade the county to provide funding to pay, equip and train 100 officers, as well as providing a headquarters and transportation for his new force covering eight divisions in Leyburn, Whitby, Pickering, Stokesley, Gilling, Easingwold, Malton and Northallerton. He served as chief constable for a phenomenal forty-two years, diligent and duty bound until he retired on 30 September 1898 at the age of seventy-five due to ill health.

He died just over a year later in November 1899. His funeral was attended by a great number of dignities from throughout the North Riding, and his coffin was carried by four police superintendents. As a mark of respect, every blind was drawn in Northallerton and Romanby as his cortege passed by. He was considered a local legend in his own lifetime.

He had married Frances Miriam Walker on 8 August 1858 and had two sons, Alan Richard and Cecil, as well as two daughters, Maude and Beatrice Mary, though the latter had died in infancy. His strong personality and devotion to duty had obviously been

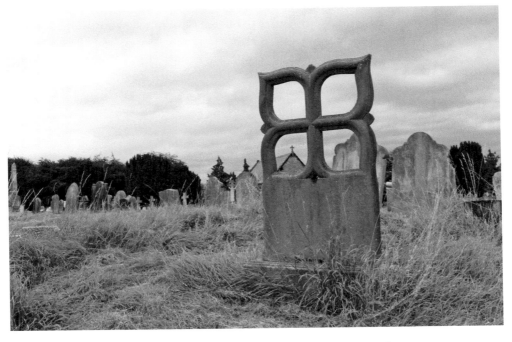

Northallerton and some
unusual gravestones.

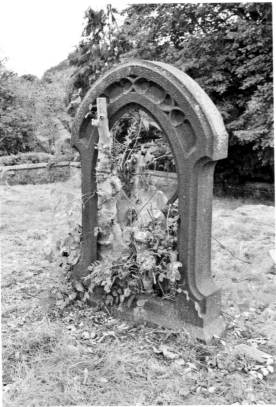

passed to his children because during the First Boer War Alan was awarded the Victoria Cross for gallantry (see below).

Major Alan Richard Hill-Walker

Displayed in the Imperial War Museum's Lord Ashcroft Gallery are the Victoria Cross and campaign medals awarded to Major Alan Richard Hill-Walker, 2nd Battalion, Northamptonshire Regiment. Alan Richard Hill (who from 1902 became Hill-Walker) was born on 12 July 1859 in Northallerton, the eldest son of Captain Thomas Hill, the chief constable of North Riding (see above), and Frances Miriam, daughter of Thomas Walker of Maunby Hall, Thirsk.

He was educated in Richmond School and joined the North York Rifles in 1877 at the age of eighteen, before transferring to the 58th Regiment of Foot in 1879 and serving in the Anglo-Zulu War of 1879. He also served in the First Boer War of 1881 as the 58th Foot became the Northamptonshire Regiment when the British army was restructured under the Childers Reforms. It was at an action during this conflict where he was awarded the Victoria Cross, the highest award for gallantry that can be awarded to British military personnel.

In the *London Gazette* of 14 March 1882, his citation read:

1st Boer War, Laing's Nek, Natal, South Africa, 28 January 1881, Lieutenant Alan Richard Hill, 2nd Bn, Northamptonshire Regiment.

For gallant conduct at the action of Laing's Nek on the 28th January 1881, in having after the retreat was ordered, remained behind and endeavoured to carry out of action Lieutenant Baillie, of the same Corps, who was lying on the ground severely wounded. Being unable to lift that officer into the saddle, he carried him in his arms until Lieutenant Baillie was shot dead. Lieutenant Hill then brought a wounded man out of action on his horse, after which he returned and rescued another. All these acts being performed under a heavy fire.

He was invested with his Victoria Cross by Queen Victoria at Windsor Castle on 13 May 1882. He continued to serve in the army in South Africa, India and Mandalay, earning further honours and rose to the rank of major. In 1902, he married Lilian Oliphant of the Walker family of Maunby Hall, near Thirsk, and he assumed the name Walker, becoming Alan Hill-Walker. He died at the age of eighty-four on 21 April 1944 in Thirsk and is buried in St Michael's and All Angels' Churchyard, Maunby.

The Booth Family

In Northallerton parish church is a grand memorial to Lieutenant Colonel Henry Booth, who was the son of William Booth and Sarah Kaye. His distinguished career is recorded on a white marble memorial with the following inscription:

Near this place is interred the body
Of Lieut. Colonel Henry Booth, K.H. of

The 43rd Regiment of Light Infantry;
Fifth son of the late Wm. Booth Esqre. of brush house,
In the parish of Ecclesfield, in the county of York:
He died at Northallerton, May 6th 1841, aged 51,

His military life was passed in the 43rd Regiment: he entered it as ensign
March 6th 1806, was promoted to be Lieut: Colonel June 29th 1830,
And retained the command of it until the day of his death.
He served with the armies in Spain and Portugal
Under Sir John Moore and the Duke of Wellington, and was present at
Vimiero, corunna, the passage of te coa, busaco, salamanca, vittoria,
And the attack on the heights of vera.

This tablet was erected by the
Officers, non-commisioned officers, and privates of the regiment,
Under his command, to record their respect for his character, and their
Esteem and affection for his gallant, generous, and amiable qualities; by which
He won the hearts of all who served under him, and infused through every rank
A high and honourable feeling.

The Booth family seem to have made money in the steel industry of Sheffield and bought the country residence at Brush in 1708. Henry Booth was born in 1790 at Brush House in Ecclesfield and joined the 43rd Regiment of Light Infantry in 1806. He served with the Duke of Wellington and Sir John Moore throughout the Peninsular War in Spain, against Napoleon, from 1807 to 1814, including some of the famous battles at Salamanca and Vittoria. On 13 April 1826, aged thirty-six, he married Mary Ann Monkhouse, daughter of Thomas Monkhouse from Romanby, at Northallerton. For a time he held the office of Justice of the Peace (JP) for the North Riding of Yorkshire and in 1835 was appointed Knight, Hanoverian Order (KH). In 1837, he had been leading his men in New Brunswick, Canada, during the Canadian revolt where he where he came down with illness. He returned to Northallerton where he died in 1841 at the age of fifty-one. His son, Henry Jackson Parkin Booth, had been born at Northallerton on 19 July 1830 and would have only been eleven years old at the time.

The memorial in the church has a further two panels, one of which is dedicated to the son of Henry Booth Sr, Henry Jackson Parkin Booth, who had entered the army as an ensign on 11 June 1847. He became a lieutenant on 9 August 1850, a captain on 29 July 1853, a major on 3 April 1857, and lieutenant colonel on 11 February 1862. The memorial panel reads:

Sacred to the memory of Henry Jackson Parkin BOOTH, Lieutenant Colonel of the 43rd Light Infantry the second son of Lieutenant Colonel Henry BOOTH, K.H., of the same regiment and Mary Ann his wife and grandson of William Booth, Esqr, of Brush House in the parish of Ecclesfield in this county. Born July 19th 1830. Died April 30th 1864. His military life like that of his fathers was passed in the 43rd Regiment in which he

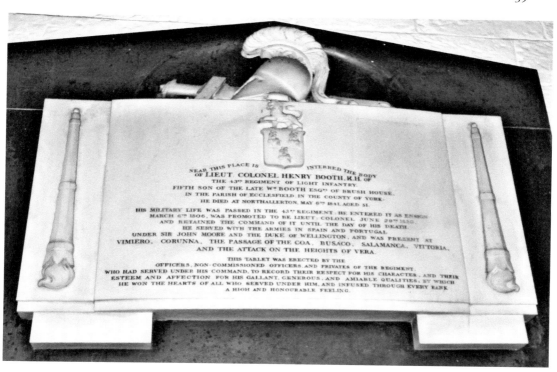

NEAR THIS PLACE IS INTERRED THE BODY
OF LIEUT COLONEL HENRY BOOTH, K.H. OF
THE 43ʳᵈ REGIMENT OF LIGHT INFANTRY.
FIFTH SON OF THE LATE Wᵐ BOOTH ESQ™ OF BRUSH HOUSE.
IN THE PARISH OF ECCLESFIELD, IN THE COUNTY OF YORK.
HE DIED AT NORTHALLERTON, MAY 6ᵀᴴ 1841, AGED 51.

HIS MILITARY LIFE WAS PASSED IN THE 43ʳᵈ REGIMENT. HE ENTERED IT AS ENSIGN
MARCH 6ᵀᴴ 1806, WAS PROMOTED TO BE LIEUT. COLONEL JUNE 29ᵀᴴ 1830.
AND RETAINED THE COMMAND OF IT UNTIL THE DAY OF HIS DEATH.
HE SERVED WITH THE ARMIES IN SPAIN AND PORTUGAL
UNDER SIR JOHN MOORE AND THE DUKE OF WELLINGTON, AND WAS PRESENT AT
VIMIERO, CORUNNA, THE PASSAGE OF THE COA, BUSACO, SALAMANCA, VITTORIA,
AND THE ATTACK ON THE HEIGHTS OF VERA.

THIS TABLET WAS ERECTED BY THE
OFFICERS, NON-COMMISSIONED OFFICERS AND PRIVATES OF THE REGIMENT,
WHO HAD SERVED UNDER HIS COMMAND, TO RECORD THEIR RESPECT FOR HIS CHARACTER, AND THEIR
ESTEEM AND AFFECTION FOR HIS GALLANT, GENEROUS, AND AMIABLE QUALITIES, BY WHICH
HE WON THE HEARTS OF ALL WHO SERVED UNDER HIM, AND INFUSED THROUGH EVERY RANK
A HIGH AND HONOURABLE FEELING.

Booth family memorial in All Saints' Church.

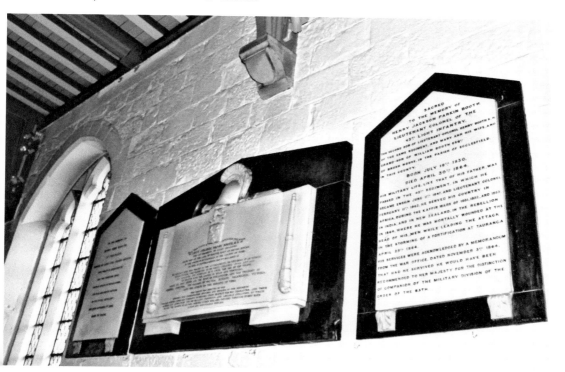

became Ensign, June 11th 1847 and Lieutenant Colonel, February 11th 1862. He served his country in Africa during the Kaffir Wars of 1851, 1852 and 1853; in India; and in the New Zealand in the rebellion in 1864 where he was mortally wounded at the head of his men while leading the attack in storming of a fortification at Tauranga, April 29th 1864. His services where acknowledged by a memorandum from the War Office dated November 3rd 1864 that had he survived he would have been recommended to her Majesty for the Distinction of Companion of the Military Division of the Order of the Bath.

Part of a colonial force, he was in command of a detachment of the 43rd, which arrived by the *Lady Jocelyn* (a ship used by the government from troop transport), sailing from Sydney to Auckland in New Zealand, where the Maoris were rebelling against British rule. The British believed the Maoris had a gunpowder store located near Tauranga, to the north of the Bay of Plenty. In order to keep a vigil on their movements the British built two forts: one called Monmouth and the other was called Durham.

The rebel Maoris only numbered 250 men but were led by Rawiri Puhirake, a strong and capable leader, as well as a good tactician. He had built a 'pa', or a hilltop fort, which included underground mazes and tunnels, and the Maoris continually goaded the nearly seven-times-larger force of British soldiers. On 29 April 1864, the British decided to take no more and 'bombarded the pa for eight hours, dropping 30 tonnes of shells upon its earthwork and timber palisading'. Expecting to 'mop up' the remaining Maoris, Lieutenant Colonel Booth at the front of 300 men, with bayonets fixed, charged the hill and took the pa with surprising ease, but the Maoris were waiting in their concealed holes. The British were surrounded inside the pa as the Maoris attacked at close quarters and massacred their foe. Thirty-five British troops were killed and at least seventy-five were injured, with minimal losses to the Maoris. Booth sustained gunshot wounds to the spine and right arm. He is said to have told Dr Manley that a Maori woman who spoke English gave him water as he lay in no man's land, but this tale is thought to be untrue. As the British retreated the Maoris managed to escape from the pa to avoid the inevitable counter-attack and loss of surprise.

Booth died the following day, on 30 April, and was buried in Tauranga's Mission Cemetery. Revenge for the defeat was soon exacted when, on 21 June 1864, the British forces found Puhirake and his men had linked up with other Maoris who were building another pa. The British attacked the unfinished defences and ended the resistance in the bloodiest of battles, culminating with the death of Puhirake.

Henry Jenkins

About a mile north-west of Northallerton, adjoining the road leading to Richmond, is a low wet piece of ground called 'Jenkin' and by sometimes 'Jenkins', which used to be covered with water during the winter months. Local lore says it was once covered with water for the whole year and abounded with fish. This tract of low land, it is said, derives its name from Henry Jenkins, the renowned centenarian, who was an ardent fisherman and a very frequent visitor to this expanse of water.

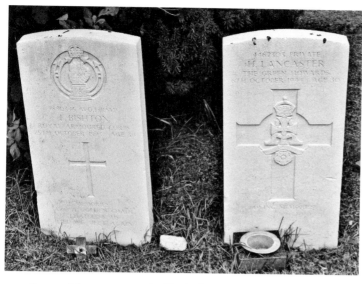

Some of the war graves in Northallerton Cemetery.

Henry Jenkins claimed to have been born in 1500, though parish registers were not required to be kept until 1538 when they were introduced by Thomas Cromwell (advisor to Henry VIII). He lived at Ellerton upon Swale and claimed to have been butler to Lord Conyers of Hornby Castle, carried arrows to the English archers at Flodden Field (1513) and swam rivers at the age of 100. Chancery Court records show that in 1667 he claimed under oath that he was aged 'one hundredth fifty and seaven or theirabouts'.

He is recorded in the register of the St Mary's Church in Bolton-on-Swale as died and been buried at the age of 169.

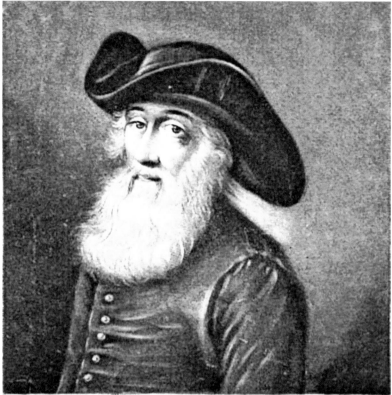

HENRY JENKINS, (who lived to the Surprizing Age of 169 Years.)
Departed this Life Dec.r 1670 at Ellerton upon Swale in Yorkshire, was 12 Y.rs old when y.e Battle of Flowden Field was fought an Sept.r 1513, he lived 16 Y.rs longer than Old Parr & was the oldest Man born since the diluge in the last Century of his Life he was a Fisherman & frequent-ly Swam in the Rivers after the Age of 100 years. He hath Sworn in Chancery & other Courts to above 140 Y.rs memory was often at the Assizes at York where he generally went on foot.
Printed for Rob.t Sayer at the Golden Buck in Fleet Street.

Henry Jenkins.

In 1743 the local inhabitants commemorated Henry Jenkins with a memorial inside the church and erected an obelisk in the churchyard.

DID YOU KNOW?
On 14 September 1721, Ann Stringer was interred in the Northallerton churchyard after having reached the grand old age of 108 years.

James Meek

James Meek was born in Brompton, Northallerton, in 1790, the son of a farmer also named James Meek. Meek Jr went to York at the age of thirteen to serve an apprenticeship

with Joseph Agar as a currier. He apparently worked in various places away from York before he returned to be married and set up his own business in Goodramgate. In time, he was involved in several businesses, including York Flint Glass Company, York City and County Bank and the York and North Midland Railway. The businesses must have been successful, as in 1846 James Meek is listed as a glass manufacturer with his home at Middlethorpe Lodge – a fine house on Bishopthorpe Road. He was a steadfast Wesleyan Methodist and resigned from the rail company in a controversy over Sunday travel. He was Lord Mayor of York in 1836, 1848 and 1850 and was also Sheriff of York 1827 as well as an Alderman from 1835 until his death in 1862.

His son, the third James Meek, later Sir James Meek, was born and baptised in York in 1815. He joined St John's College, Cambridge, in 1837, but left to work within his father's business interests. He was a Liberal councillor for Bootham Ward from 1849 to 1853, and an Alderman in 1853. He was a Wesleyan Methodist like his father until 1853 when he became a Primitive Methodist and an active member of Little Stonegate Chapel, York. He was Lord Mayor of York in 1855, 1865 and 1866 and was also instrumental in establishing Elmfield College.

Sir James was chairman of York City and County Bank, Governor of Bootham Asylum and treasurer of the York Mission. He was also a freemason in the York Lodge No. 236, Worshipful Master 1864, and a major commandant of the 1st West Yorkshire Rifle

Brompton Church.

Volunteers. In 1869 he was 'knighted, somewhat belatedly, for his hospitality to the Prince and Princess of Wales on their visit to York in August 1866 when they attended the Yorkshire Fine Art and Industrial Exhibition in the grounds of Bootham Park Hospital, the annual show of the Yorkshire Agricultural Society and the Great Volunteer Review of 21,000 troops, both on the Knavesmire'. Both of them lived at Middlethorpe Lodge and are buried in York Cemetery.

Robin Horton

In 1765, the Annals report there lived at Northallerton one Robin Horton, a chimney-sweeper, who had two club feet, and what was more remarkable, his wife also had a club foot, but not only that he was the owner of an old grey horse who also had one club foot.

Robin Horton and his family were not very popular with his neighbours as he was considered a tall ruffian with appalling manners and his 'countenance extremely unprepossessing' or perhaps in today's words, he was considered extremely ugly. His wife was also labelled similarly with 'a most disgusting appearance and depraved habits', but nevertheless they had managed to produce three sons and two daughters, who were also regarded as dishonest and ill mannered. Even with all this local disgust, Robin Horton did business for all the nobility for miles around and he, along with his horse were seldom seen apart. Though it had often been noticed that every night after dark they went out together, no one knew where, and seen returning home using lesser known paths long after midnight. Suspicions of ill deeds were aroused, but as no proof of any crime could be substantiated against him, so everyone kept their uncertainties to themselves for fear of a 'sound drubbing' from the father or the sons.

These suspicions went on for several years, when one morning the mansion of a wealthy gentleman in the neighbourhood was discovered to have been broken into during the night, and valuables carried away. It was the depth of winter and snow was lying thick upon the ground, so the officers examined the ground minutely around the mansion hoping to find tracks. There in the snow, they distinctly traced the impression of three club feet, and with suspicion immediately falling on Robin, the officers followed the footmarks directly to the residence of Robin. The property was discovered in a cellar underneath his house, and the father and two of his sons were detained, and eventually committed to York Castle for trial. One of the sons turned king's evidence against his father and brother, and they were transported for life.

Robin Horton's wife and the son continued with the chimney sweeping business, but because of their character now known, it was very difficult to generate much business and yet they seemed as prosperous as ever. A short time later they were discovered breaking into the residence of a Lady and the mother, son, and two daughters, were all apprehended in the act, with the old grey horse with the club foot, found at a short distance away waiting to carry home the plunder. For this burglary, the whole of this infamous and remarkable family were transported for life, and the poor old horse was shot.

Grade II listed old police station doors.

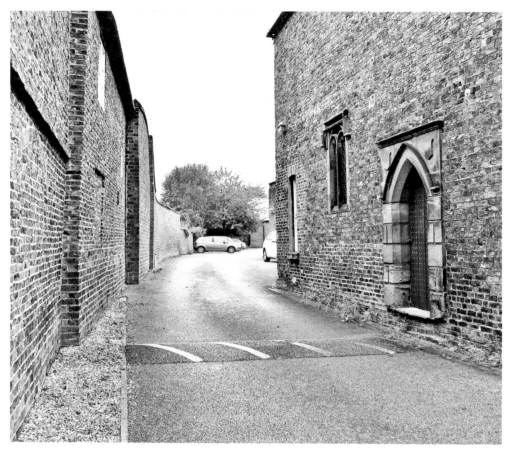

Side wall to the old police station.

Murder at Maiden Bower

In July 1727, William Stephenson, a grocer from Northallerton, was tried at Durham and sentenced to death for the murder of Mary Farding (or Fawden). He had thrown Mary into the sea, who was pregnant by him, at Hartlepool, near the Maiden's Bower. The Maiden Bower is a small rock detached from the Town Moor and a few yards to the north of what is called the East Battery, now a museum. There is a ballad called 'The Hartlepool Tragedy' based on the confession and dying words of William Stephenson, who at the age of twenty-seven was executed at Durham on Saturday 26 August 1727. The words were supposedly taken from his own mouth the night before his execution, by a person that went to visit him in the gaol. One of the verses represents him as having lashed the girl to her death:

> She dreading her fate, alas! when too late,
> Did call out for mercy, whilst I did her beat,
> With the whip in my hand. She, not able to stand,
> Ran backwards, and fell from the rock to the strand.

From another verse we can take it the reason for her demise is that Stephenson was a married man:

> I feared she'd breed strife 'twixt me and my wife,
> And that all my friends would lead me a sad life,
> Then Satan likewise did join each surmise,
> And made me a hellish contrivance devise.

The Lascelles Family

During the reign of Edward I, Allertonshire sent two members to Parliament, but for nearly 400 years the privilege was in the main suspended, and it was not till 1640 that it was again resumed, by order of the House of Commons. Francis Lascelles was a member of the landed gentry from an old Yorkshire family whose residence was at Stank Hall, near Northallerton. The Lascelles served in the parliamentary army, but he states he

Alleyway, ginnel or snicket.

Yards were often working spaces behind the shopfronts.

'exercised his command with moderation', and became the first of his family to be elected when he was returned for Thirsk as a recruiter. He served as one of Charles I's judges, but refused to sign the death warrant, though he continued to sit in the Rump Parliament and represented the North Riding of Yorkshire under the Cromwell Protectorate. He was clearly a shrewd man for after removal of Cromwell's son and seeing the future restoration of the monarchy, he favoured the return of the secluded Royalist Members. He was discharged from Parliament for his part in the trial anyway.

Later the Lascelles continued to be influential and Thomas Lascelles would represent the family in 1688, 1690–95 and 1695–97. Daniel Lascelles was Member of Parliament for Northallerton in 1702, and High Sheriff of Yorkshire in 1719. Edwin Lascelles, born in 1713, became MP for Scarborough and for Northallerton in 1754, and created Baron Harewood, of Harewood Castle, in 1790. In 1759 he laid the foundation of Harewood House, which became and remains the residence of the successive earls of Harewood.

The family's influence is further emphasised by a strange tale from the archives, where on opening a small vault in the south transept of Northallerton Church in February, 1814, in order to inter the remains of the late Revd Benjamin Walker, a lead coffin containing the body of the late Henry Lascelles was discovered. The outside wooden coffin was quite decayed, but the lead one was still in good condition and upon the lid was a piece of lead with the inscription, 'Henry Lascelles, esq., died October 6th, 1753, in the 63rd year of his age.' There was another square brass plate, with the same inscription upon it, laid next

to the lead one, which had probably been fixed to the lid of the outer decayed wooden coffin. The remains of the Revd Benjamin Walker were deposited on the north side of the said coffin.

Henry Lascelles was born in England, probably at Stank Hall and was a wealthy Barbados plantation owner. He was the grandson of Francis Lascelles, son of Daniel Lascelles and Margaret Metcalfe (another important local family) and he also served as Collector of Customs for the British government in Barbados. He was a director of the British East India Company 1737–45, a financier, and Member of Parliament for Northallerton. He is said to have been in the financial upset of the South Sea Bubble, where he amassed considerable wealth to the detriment of many investors. Henry Lascelles committed suicide in 1753 by slashing his arm's veins and later his remains were brought to Northallerton Church to be deposited by the side of his ancestors. At the time it is reckoned he was one of the wealthiest men in England.

The Lascelles family, who had been around since the thirteenth century, became increasingly prominent and politically involved in Yorkshire, owning a great deal of land near Northallerton and the Vale of Mowbray. They must be considered one of the most influential families in the town's long history.

5. Buildings

All Saints' Church

It is believed that a church has occupied this site since the seventh century, when St Paulinus built a church of stone. Paulinus was a missionary sent in the early 600s from Rome by Pope Gregory I to Christianise the Anglo-Saxons, becoming the first Bishop of York around AD 627. After the restoration of the church in 1883–84 some stonework from this period was found and built into the walls, along with other sections of ancient cross left loose about the church. Later, in the Anglo-Saxon period, the lands were divided into shires; 'Allertonshire' is referred to in the Domesday Book, with Northallerton and its church at the centre.

Before the Norman Conquest the land around the area belonged to Earl Edwin, who was soon ousted following the Norman move north and the suppression of rebellious lords. The land at Northallerton remained with the king until sometime after 1086 when the church was granted to William de St Carileph, the first Norman Bishop of Durham.

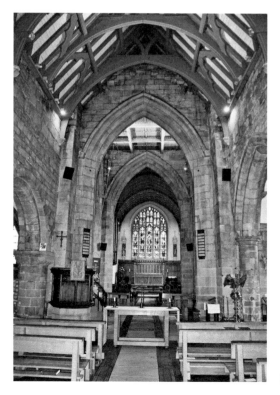

Inside All Saints' Church.

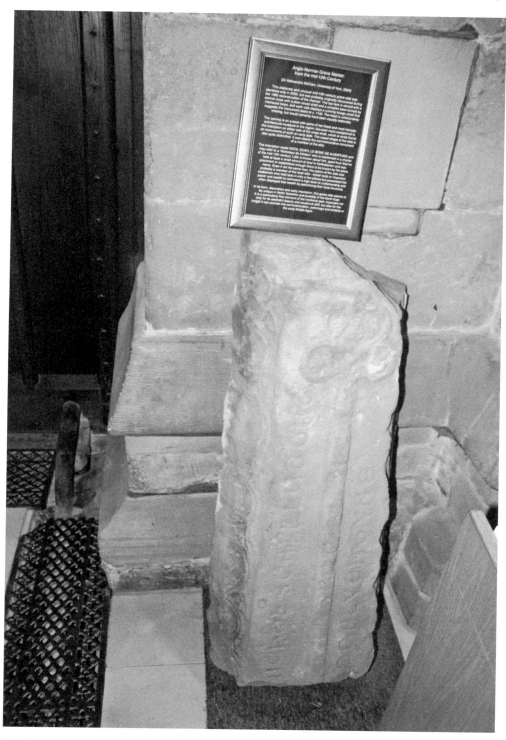

Ancient stone within All Saints'.

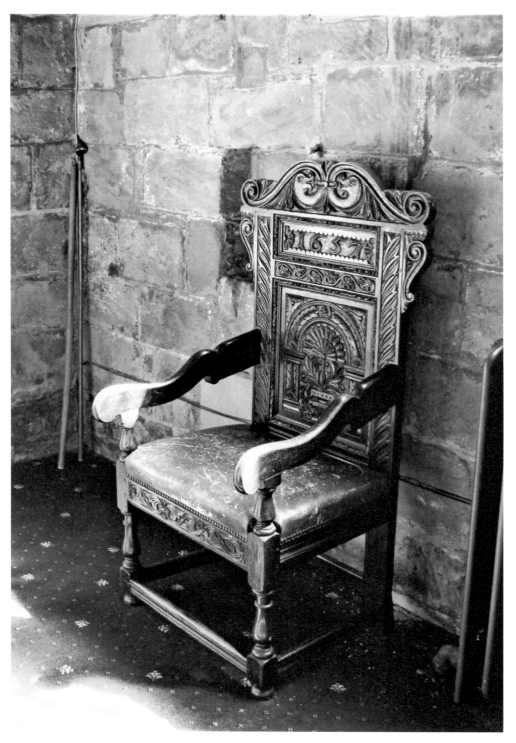

Late seventeenth-century chair.

Statue of Our Lady with the infant Jesus.

Though Northallerton was part of North Yorkshire, the church remained with the Bishop of Durham until 1830, when the it came under the diocese of Ripon (later the Bishop of Whitby) as part of York.

The first church would have been a very simple building: a rectangular nave with a connection chancel, which was altered over the years as the congregation grew. The church was given a major refurbishment around 1220 when transepts were added, a new chancel and many other details based on the religious practices of the time. After the Battle of Bannockburn in 1314, the lands of the north were susceptible to Scottish raids and indeed Northallerton was set to the torch three times. Marks from the fire can still be seen in the church. Once these raids settled down and the Scots had been defeated at the Battle of Neville's Cross the church was rebuilt and increased in size, and in the fifteenth century Bishop Neville added the fine Gothic window.

The following inscription, now defaced, appeared upon a 1381 tablet in the parish church:

> This church was rebuilt after its de-
> struction by the Scots in 1318, by Thomas
> Hatfield, Bishop of Durham, assisted by the
> Munificence of his royal master King
> Edward III. Of blessed memory. A.D. 1381.

The church at its height in the late fifteenth and early sixteenth century would have been an ornate and richly decorated building, but this would change during the Reformation and suppression of the Catholic Church. Many wall paintings were whitewashed over, effigies and some stained glass was removed, and the vandalisation of some churches even removed intricately carved partitions and furniture. A further simplification of the church and its rights was imposed during and after the Civil War.

By the late 1700s the chancel was described as being ruinous and dangerous. It was demolished and rebuilt. Later further structural damage was advanced by poor roof work and modifications throughout the nineteenth century. As with many churches in the country, the Victorians carried out significant modifications, and All Saints' was no exception. In 1882, modifications were carried out, including a new roof with a higher pitch, the choir was moved to the chancel and plasterwork was removed from internal walls. The paintings on the north wall were uncovered during these works. The chancel was then totally demolished and replaced; it was here where fragments of ancient crosses and medieval stone coffins were found.

DID YOU KNOW?
Edward VI had all plate and bells removed from churches in 1553, apart from those items required for the sacraments.

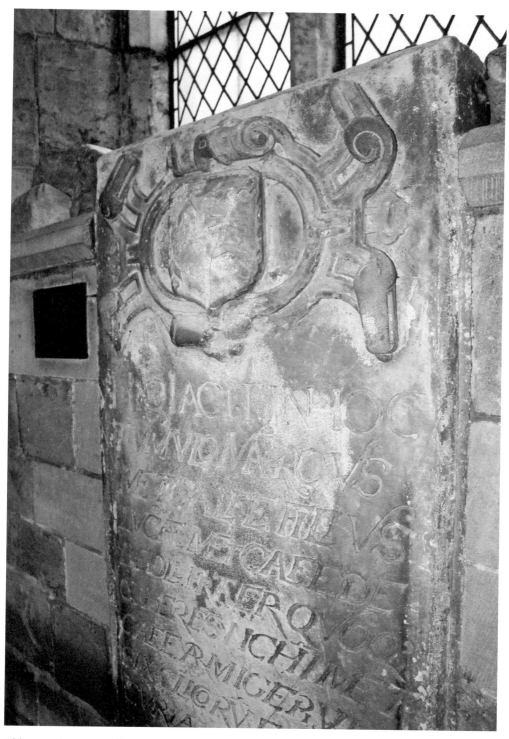

Oldest tombstone in All Saints' Church.

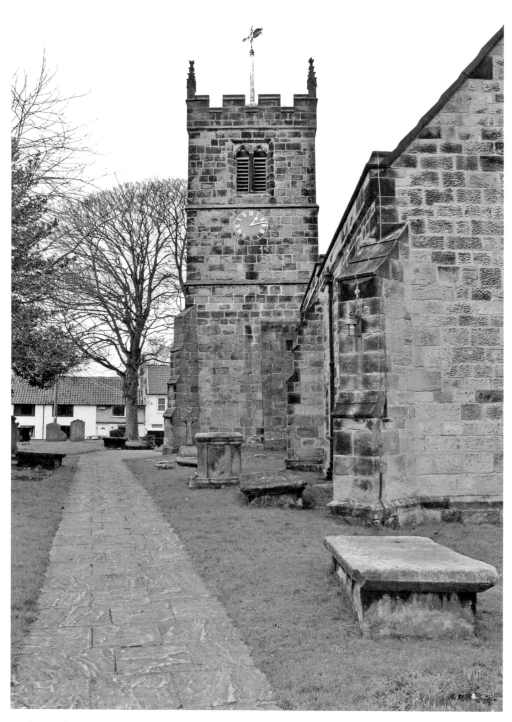

St Thomas's, Brompton.

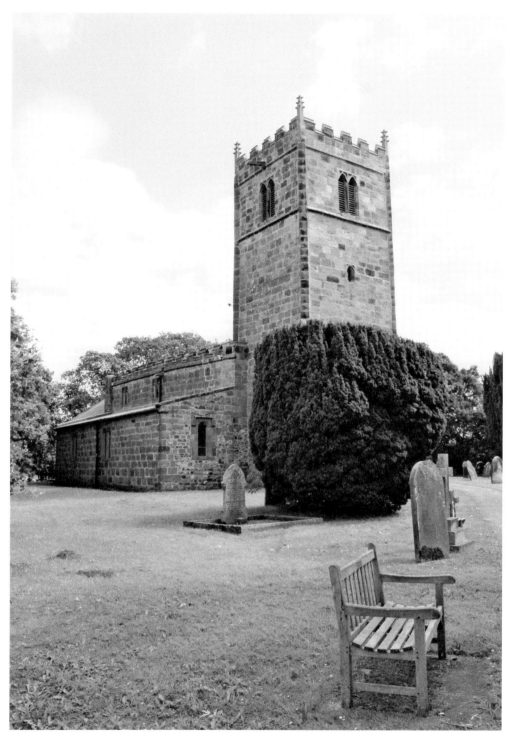

Danby Wiske Church.

St Thomas's Church, Brompton

St Thomas's in Brompton was built in the twelfth century with modifications in the fourteenth and fifteenth centuries and a later mid-Victorian restoration. However, the date of the site was rewritten when a number of hogback tombstones were discovered along with an Anglo-Danish cross shaft with head. Six of the hogbacks were taken to Durham Cathedral Library, leaving four whole ones and a few fragments at St Thomas's. In fantastic condition they depict carvings of bears hugging the slabs with strapwork in their mouths and typically date from between the tenth and eleventh centuries.

Danby Wiske Church

Danby Wiske church is unusual in that its dedication is unknown because the records were destroyed during a raid by the Scots, but has a great deal of history contained within its walls. It is thought the site dates back to Saxon times, thought the church is Norman in construction, and parts of this older church are built into the one standing today. Above the door is a Norman Tympanum from c.1090 to 1120 and is the only one in North Yorkshire still in situ. The church also contains a Norman font, Jacobean pews and other medieval features.

> DID YOU KNOW?
> The Danby Wiske section of the 192-mile (309-km) Alfred Wainwright Coast to Coast walk is at the lowest altitude on the whole route.

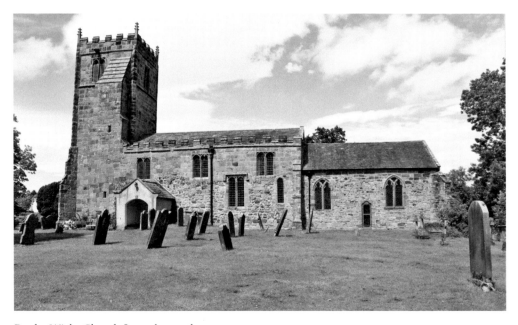

Danby Wiske Church from the south.

Norman tympanum.

Market Cross

Market crosses are usually located near the church to signify 'fair dealing and the right to hold a market', and Northallerton was no different. The market was originally held in the vicinity of the church at the north end of the town until at some point before the sixteenth century, when it moved further south between the butcher's shambles and the toll booth. When the shambles and toll booth were demolished in 1872–73, a Mr Jefferson purchased the cross and placed it in his garden. In 1913, the cross was resited in the High Street, a little south of the relatively new Town Hall, where it stayed until 1987 when it was moved to its current position during the refurbishment of the whole street.

Toll Bar and Shambles

To the north of the town's main street there used to be two double rows of butcher's shambles, then the market cross and slightly further south a toll booth, which was first mentioned in 1334. William Hutton, in his book *Trip to Coatham* says, 'North Allerton is a handsome town, consisting of one very wide street perhaps fifty yards in breadth, but injured in the centre by a shabby set of butcher's shambles: nor would a handsome set be an ornament, but spoil a spacious street.'

To the south side of the Shambles was the toll booth – an old unsightly building. Its ground floor is divided into shops and a large room has been built over where the quarter sessions used to be held. The tolls were collected by the Ecclesiastical Commissioners as part of the Bishop of Durham grants. As with many towns during the eighteenth century these market halls, shambles or moot halls were considered poor for the air flow of the street, and many were removed or rebuilt in a new style. Penrith, Barnard Castle and Kendal all had their market areas freed from obstructing buildings during this period. In Northallerton one of the reasons may have been the pestilence of rodents or other vermin: 'The migratory habits of rats are well known, and it is said that in several instances large

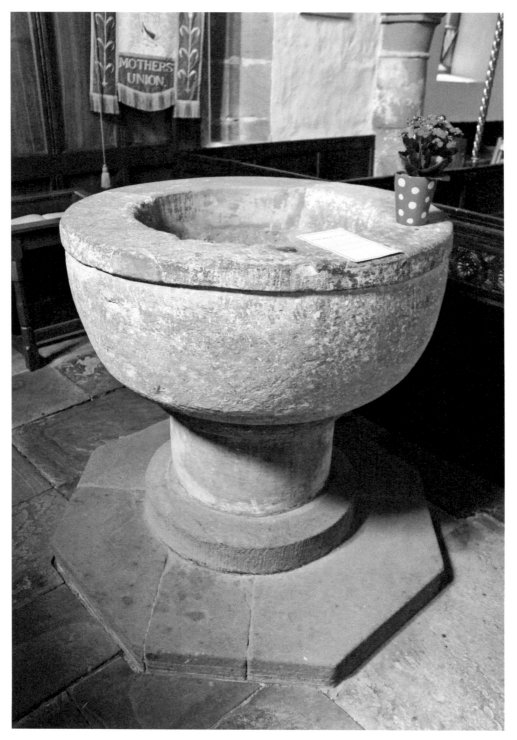

Norman font.

Market cross.

Market cross plaque.

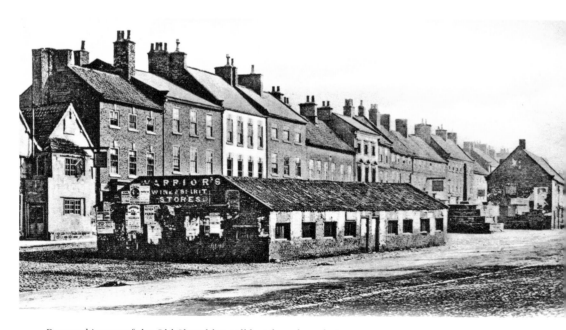

Postcard image of the Old Shambles, toll booth and market cross.

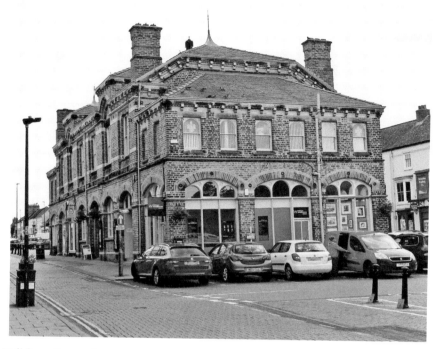

Town Hall from the north.

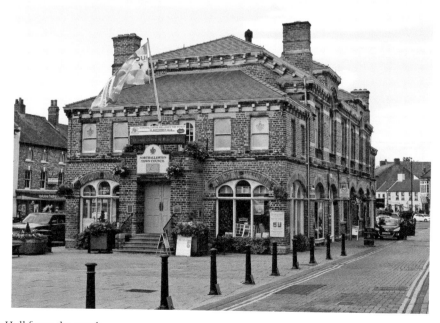

Town Hall from the south.

numbers have been seen to proceed from this building to drink at the Sun-beck when swollen.' The stocks once stood on the south side of the toll booth, but by this time had already been done away with.

On 14 March 1872, the demolition of the unsightly old shambles commenced and in the same year the new foundation stone of the new Town Hall was laid, but there was no elaborate ceremony to mark the occasion. Messrs Ross & Co. of Darlington were the architects, and Messrs A. Peacock & Son of Northallerton were the principal contractors. The old toll booth, which had for several generations occupied a prominent position in the centre of the town, was sold by auction on 20 August 1873 to Mr Percival Hindmarch of Northallerton, who purchased the market cross at the same time, which then became the possession of W. T. Jefferson, esq. The toll booth had for some time previous to the erection of the prison been used as a receptacle for prisoners, as a courthouse and a place of assembly for public meetings. It was removed in the following month and this ancient building was lost from the streets of Northallerton. However, in its place and completed on 22 December 1873 was the new well-proportioned and more useful Town Hall, which was erected on the site of the old Shambles and inaugurated with a concert then opened to the public.

Carmelite Monastery

To the east of the parish church, on the site of the Friarage Hospital, there used to be a Carmelite monastery. The Carmelites were originally known as the Order of the Brothers of the Blessed Virgin Mary of Mount Carmel and may have been founded during the Crusades by a community of hermits on Mount Carmel in Palestine.

The monastery was founded at Northallerton between 1354 and 1356 by Thomas Hatfield (Bishop of Durham), John Yole (a local merchant) and by a licence granted by Edward III. John Yole gave a croft and pasture together containing 3 acres and 1 rod upon which to build them a religious house. The bishop granted 6 more acres the following year and the king carried out a commission to build the friary. Lord Neville is also said to have built a complete church within the grounds, and the wife of John Yole was buried here. The first prior is believed to have been called William Kellaw, who lived, died and was buried there too. Leland claimed Kellaw was born in Northallerton and was known to be the confessor to the Neville family, who were well-known benefactors of the Carmelites in Northallerton.

Nothing remains of the site, and even in *The History and Annals of Northallerton* (1885) J. L. Saywell commented, 'The site is situated on the east side of the town near the church and still retains the name of the Friarage: no vestige remains save the modern wall which was built of stone from the old fabric.'

In the years following 1356, the monastery received numerous bequests from the local lords and ladies, with several thought to have been buried here, including Lady Margaret Percy, daughter of Lord Neville of Raby Castle. In 1503, Margaret, the eldest daughter of Henry VII, complete with her entourage, stayed at the bishops' palace on her way to Scotland to marry James IV. The *Somerset Herald* described the visit and stated the queen departed from Newbrough to Allerton and was received by the vicar and folk of the church, with the Carmelite friars in procession. The Bishop of Durham was also in attendance to greet his important royal guest.

Friarage Hospital site.

The next few years were to prove to be a troubling time for the order due to Henry VIII's dispute with the Catholic Church and his marriage to Anne Boleyn. The Act of Supremacy in 1534 established the monarch as the head of the Church of England – a contradiction to the Catholic friars' obedience to the pope. In that year all friars had to be assembled in every monastery and examined concerning their faith and had to take an oath of obedience to the king, as well as Queen Anne. They had to be bound by oath to preach and persuade the people of the above at every opportunity. They must acknowledge the king as the Supreme Head of the Church and that the Bishop of Rome has no more authority than other bishops. Each house must be obliged to show their gold, silver and other moveable goods, and deliver an inventory of them.

In 1538, Henry's minister, Thomas Cromwell, pursued a campaign against the 'old religion' known as the Dissolution of the Monasteries and appropriated their income and assets to the Crown. This enabled the king to increase the treasury and grant lands to pay for his military campaigns. In the same year on 20 December the surrender document was signed by the prior, five friars and five novices. The surrender document is preserved in the Public Record Office as 'Prioratus Fratrum Carmelitarum alias dictus Alborum infra villam de Northaluertone in Com. Ebor. 20th Dec 30 Hen. VIII.'

In *Leland's Itinerary* (1539–43) he refers to a house in the past tense, which must be the Carmelite friary: 'Ther was a house of ... freres in the est side of the toune.' In 1553 the friary lands were granted to Richard and Henry Vavasour and in 1746 a poem describes the 'old Friarage shews its bending walls' and 'its swelling terras, and encircling trench'. So clearly there were still some discernible features remaining in the 200 years since its dissolution. In 1791, Thomas Langdale mentions the 'site was granted to Richard Vavasour of Birkin, and Henry Vavasour of London, from whom, through various possessors, it at length came to the late Robert Raikes Fulthorp, esq.; who sold it to William Wailes, esq. It still retains the name of the Freerage, and the terrace, and some foundations of the out walls are still discernible.'

The land was used for farming until the mid-1800s, when in 1857 a new workhouse was built on Friarage Fields and it seemed that all that remained was a wall built from the old stone. In 1858, the property passed to John Dixon and later to William Thrush Jefferson and Cuthbert Wilson. In the same year, on 3–5 August, the Great Yorkshire Agricultural Show was held in the Friarage Fields. Throughout the nineteenth and early twentieth centuries the fields continued to be used for shows and the Northallerton Agricultural Show. At the same time the western edge of the Friarage Fields were worked as a gravel pit, and considerable amount of remains from the friary were unearthed. It is said several cartloads of human bones were found near to Brompton Lane, and in 1887 six perfect skeletons under large slabs were uncovered by workmen who were levelling the field. Over the following years stained glass, glazed tiles and more human bones have been discovered, including when war trenches were dug and when building works were carried out. The remains of eight Carmelite friars were uncovered as part of an archaeological dig before Priory Close was built in Northallerton; they, along with other friars' remains found in Newcastle, were reinterred by the Carmelite Order at the Jesmond Old Cemetery.

In 1939, the workhouse became an Emergency Medical Hospital in case of bombing in the Teeside area. After the war the hospital was used by the RAF until in 1947 when it

North Eastern Rail line to Teesside.

became a civilian hospital, and has continued as a general hospital up to the present day. I was actually involved in the construction of one of the new buildings on the site and I am very proud to have added to the history of this site.

DID YOU KNOW?
Until 1956 the gateway entrance of the friary was still visible, built into the wall of the now demolished Bell and Goldsbrough lemonade factory.

Northallerton Poorhouse

The original poorhouse was within the former Guildhall, erected in 1444 and located to the west of the High Street near the Sun Beck. In the 1730s when it stopped being used for the quarter sessions, it became the poorhouse. A parliamentary record of 1777 recorded there was space for twenty-eight inmates, and further records from 1816 claim it took three days for the workhouse yard to be cleared of the accumulated rubbish.

St James Hospital

Situated to the east of the Thirsk Road on the south side of the town is Spital Farm, and the clue is in the name. Here Philip de Poitou, Bishop of Durham (1197–1208), established the St James Hospital, which was predominantly a leper hospital for thirteen patients and further to this the local poor were given simple food at the hospital gate. They would

Old postcard of the Cottage Hospital.

also care for needy travellers who could be lodged in the hospitium (meaning hospitality, especially of a guest) at the entrance. The hospital was well endowed with local land, but when visited by an Archbishop of York in 1379 was said to be in poor condition and steps were taken to improve the building and staffing. In 1540, the hospital was dissolved along with other monasteries, at which time there was 'a master, three chaplains, four brethren, two sisters and nine poor people'. What is often not realised about the Dissolution of the Monasteries is that while many monastic sites certainly were corrupt and had great wealth, they did look after great numbers of the poor, which must have led to great suffering on their part.

HMP Northallerton

HMP Northallerton is, at the time of writing, being demolished to make way for a new mixed-use development, but has been home to tens of thousands of inmates over its long 230-year history. Built in 1783 as a house of correction, it has the distinction as being one of the first custom-built jails in England and is significant in the history of penal reform.

The house of correction was built on the site of a pond used for watering horses, the like of which was also at the entrance to the friary, and a piece of waste ground granted by the Bishop of Durham to the justices of the North Riding. The land was low and swampy and often used as a rubbish tip for the town over the years; however, its main use was for the washing of posting and coaching horses at the time when the horse and coach, or carriage, was the main form of transport.

Invented by engineer Sir William Cubitt in 1818, treadmills, or the 'everlasting staircase' as they were also known, were introduced at Northallerton in the 1820s. It was basically a

Rear of the Golden Lion Hotel (originally stabling).

long cylinder surrounded by steps and as the prisoner put weight on a step it depressed, forcing inmates to keep climbing as the cylinder rotated. It was designed to occupy the prisoners' time and to teach them the value of work. They were forced to walk on them for hours and could be used to power water pumps or grind corn, but were abolished in 1898 with the passing of the Prisons Act.

> DID YOU KNOW?
> Before it was built, at the south-east corner of the site of the prison, there used to be a pinfold or a pound for stray animals?

Porch House

I feel sure every medieval town in England has a legend of a secret tunnel, and indeed with every town I have researched so far this has been true. In Northallerton that secret tunnel is said to be from Porch House to the church, but whether it is true or not Porch House has many other stories to divulge.

As the oldest private house in Northallerton, built around 1584, the building has played a significant part in British royal history, or at least a part in one of the most turbulent

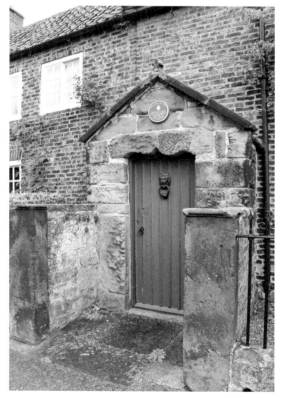

Above: Porch House.

Left: Porch House entrance.

times in British history. Richard Metcalfe obtained some land in Northallerton from a prominent local family and cousins to Mary, Queen of Scots, and decided to build a 'Vernacular Crook Beam House, from cobbles, dung and chuff, with a thatched roof'. Though the building has undergone changes over the years some parts of the old house construction are still visible, including wooden beams, wattle-and-daub walling, and a staircase. The deeds for the house still survive in the North Yorkshire County Records Office and a copy is kept at the house. During renovations in 1844 a beam with the inscription 'RM 1584 MM' was exposed to confirm the Richard Metcalfe connection.

Charles I is said to have used Porch House to reside on some of his trips north, but more significantly he was held here under arrest during the Civil War after being sold to Parliament. On 5 May 1646 Charles surrendered to the Scottish forces at Newark and was taken north to Newcastle (via the north road, so may have passed through the town again). After negotiations Parliament agreed to pay the sum of £400,000 ransom for the king and over January 1647 the monies were transported north, under heavy guard, to pay the Scots. In February 1647, he was held at Porch House as a prisoner of the Parliamentarians during his route south to London. A local legend tells of his attempt to escape via a window aided by the sympathetic Metcalfe family.

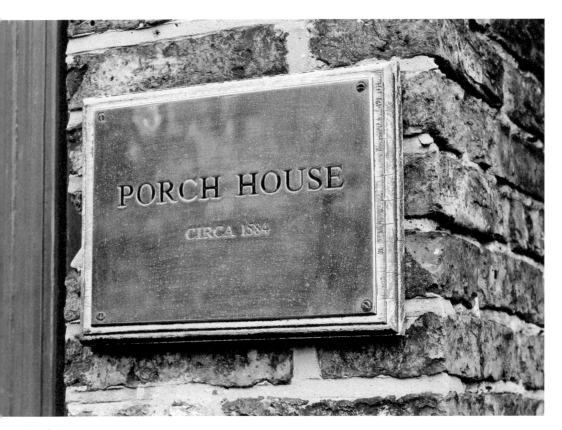

Porch House.

In 1674 the Metcalfes changed their name to Marwood in order for William Metcalfe to inherit his wife Anne's vast Busby estates, and these descendants owned the house until 1988. The house is now an attractive guest house in the centre of the town.

DID YOU KNOW?
On 21 January 1647, the payment of £200,000 to the Scots for the captured Charles I took place in Northallerton.

Royal Observer Corps (ROC) Monitoring Post

Some of the secret parts of Northallerton are not so far back in the town's history. In a field just off the Thirsk Road (A168 south) is a Royal Observer Corps monitoring post. Opened in 1961, most of the facility is underground and was originally designed to detect radioactive fallout and communicate with other posts in the region. The posts were grouped together to form a cluster of between two or five posts and were uniquely numbered, with one post in the cluster selected as the master post. There is another one located at Bedale and you can visit ROC 20 Group Control in York as it is managed by English Heritage. The York Cold War Bunker is a two-storey, semi-sunk former Royal Observer Corps Group Control building in the Acomb area of the city. Most of the posts were closed in 1991 following the cessation of the Cold War.

The post is locked up and not accessible to the public, but during its operation it would have been manned twenty-four hours a day and contained bunk beds as well as the maps, communication devices and sensors required to fulfil its purpose.

ROC Station. (Courtesy of www.subbrit.org.uk)

Yafforth Hall

The hamlet of Yafforth lies to the south of the ancient parish of Danby Wiske, just to the west side of the River Wiske; its name was derived from the ford crossing the river at this point. To the north is Howe Hill, a motte-and-bailey castle originally built to protect the crossing and still standing some 4.6 metres (15 feet) tall. The village is a collection of a few houses following the road, with a church situated on the east side closer to the river. Behind the church, on the east side, is Yafforth Hall, a splendid rectangular brick building that appears to have once extended to the south, evidenced by the lines of large boulder foundations. The building was originally plastered, but most of the plaster has now fallen away, exposing the brickwork, some round-headed windows and cut-brick mullions. Below the eaves on a wall, which may be original, is the date '1614'. The building is two storeys, has two gable-ended bays and a fine pantile roof. The hall has been altered and renovated over the years, but is an impressive building and is sometimes known as the Jacobean House.

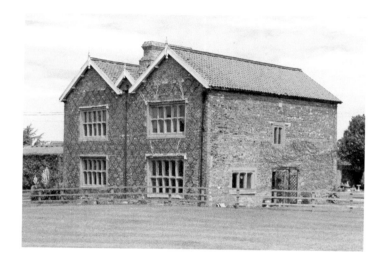

Yafforth Hall.

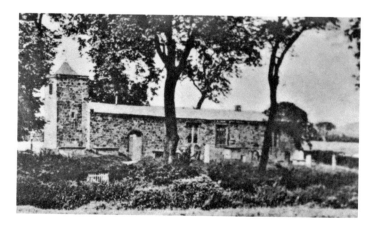

Yafforth old church before restoration.

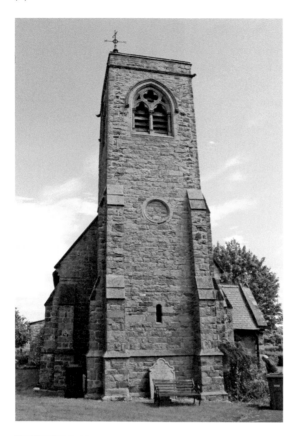

Yafforth Church and gravestones.

Public Houses and Inns

The town has always been an important point on the Great North Road and was a regular stopping-off point for the travellers heading north or south. Situated around 30 miles north of York and 45 miles south of Durham, Darlington is around 15 miles north and Richmond only 15 miles west. To accommodate this passing trade the town was well endowed with hotels and inns. The amount of time from London to Edinburgh changed over time as roads improved, carriages were modernised and horse teams were changed. The early 1800s were the golden age of the stagecoach. They could travel at around 12 miles per hour, with four coaches per route, two going in each direction with two spare coaches in case of a breakdown.

The standard and the sign depicting the battle.

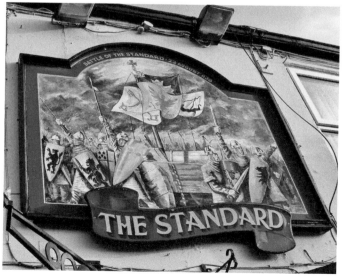

Oddfellows Arms.

Nags Head.

Below is a list of the hotels and Inns at Northallerton from the 1823 *Gazetteer*. The list also includes the names of the landlords at the time:

Black Bull, Robert Smith
Black Swan, John Simeson
Durham Ox, Robert Thompson
Fleece, William Guthrie
George and Dragon, George Watson
George Inn, Dorothy Clithero
Golden Lion, Francis Hirst, (commercial Inn and posting house)
Kings Arms, Charles C. Cade
King's Head, W. Scott, (and posting house)
Lord Nelson, Thomas Walker
Mason's Arms, Alice Wallis
New Inn, William Humphrey
Oak Tree Inn, Thomas Masterman
Old Golden Lion, John Caris
Pack Horse, Robert Simpson
Talbot Inn, Thomas Wright
Three Tuns, John Tyreman
Victory, Thomas Robinson
Wheat Sheaf, Charles Kingston
White Horse, William Grundy

The Golden Lion Hotel.

The Golden Lion Hotel

The present Golden Lion is believed to have been built around 1730 by Robert Richardson and became very important as a coaching inn, having extensive stabling at the rear. The hotel has a considerable number of links with famous people, including John Wesley, who is said to have preached here in 1745. Several politicians held rallies, victory speeches and many meetings took place here. In 1816, Grand Duke Nicholas, later Tsar Nicholas I, stayed overnight on a grand tour of Britain, and Queen Victoria's son, the Duke of Connaught, rested here on his journey to Edinburgh. Andrew Carnegie, the millionaire and philanthropist, spent a weekend in June 1888 and General Booth, the national leader of the Salvation Army, stayed in 1904. Many other guests have stayed at the hotel over the years and it still feels central to the town.

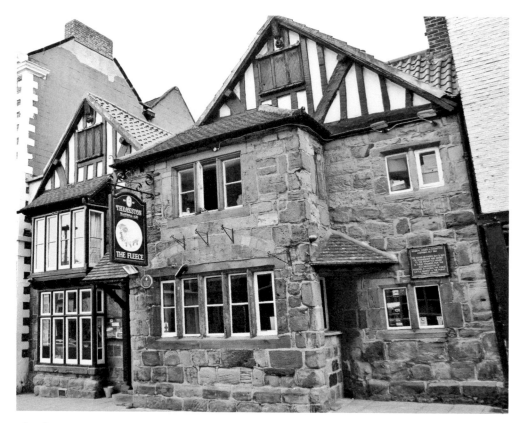

The Fleece on the site of Austin Friary.

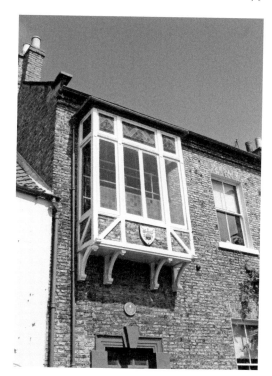

Vine House window.

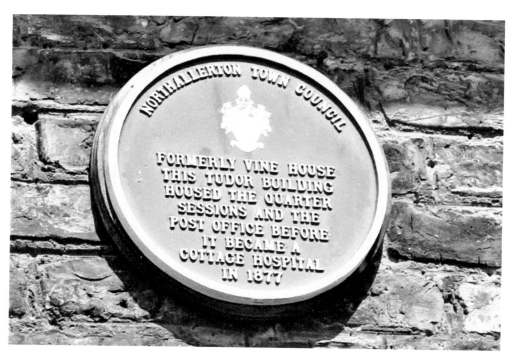

Plaque.

Northallerton Racecourse

The area between Thirsk and Scotch Corner, Middleham to Northallerton had a distinguished period of well-renowned fine horse racing and breeding during the golden years of the eighteenth and nineteenth centuries. There were once racecourses at Richmond, Gatherley Moor (near Scotch Corner), Bedale and Northallerton, as well as the remaining ones at Catterick, Thirsk and Ripon.

The earliest recorded meeting at Northallerton was Tuesday 15 October 1765 when a three-day meeting was staged with £50 prizes offered for each of the three races. These early meetings were held at Otterington 'on a course that was an unusual triangular shape of just a mile, although the bends were not tight. There was a sprint course of 6 furlongs which joined the main course' and there was a small grandstand built to accommodate some of the racegoers.

The Members Plate was the main prize in the late eighteenth century, which was won by Mr Burdon's horse – Duchess – on 11 October 1782, but in the nineteenth century the main race was the Gold Cup, which was won by Mr Haworth's Minna on 15 October 1824.

James Whyte's *History of the British Turf* records that in October 1839 the races were the Northallerton Town Plate, the Northallerton Gold Cup and the Northallerton Silver Cup – all over 2 miles long.

The final meeting to be held at Northallerton was on Friday 22 October 1880.

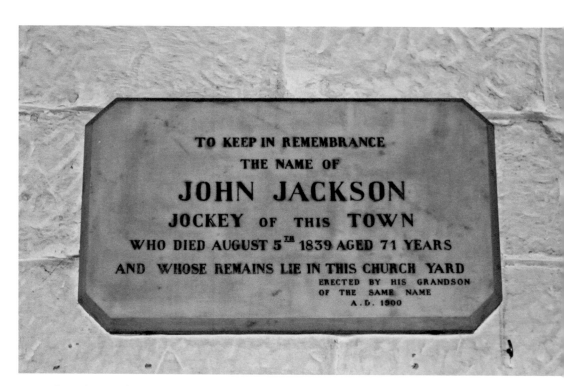

John Jackson jockey memorial in All Saints' Church.

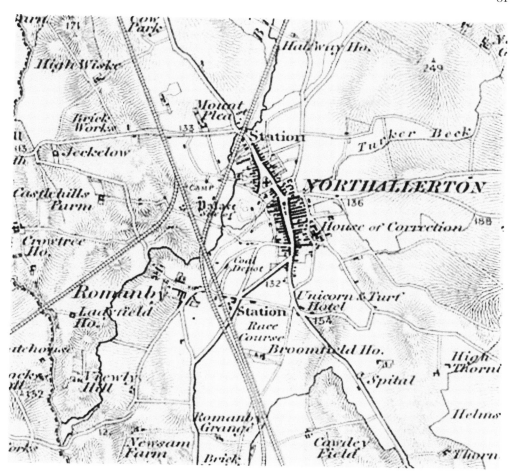

Racecourse shown on map.

6. Tales From the Archives

Sockburn

The parish of Sockburn lies around 9 miles to the north of Northallerton in a peninsula formed by the River Tees. As early as AD 780 the village was recorded as 'Soccabyrig', which may have meant 'Socca's Fortified Place' (Byrig meaning fortified) or 'Fortified Place of Soke' where 'Soke' is the Anglo-Saxon word for a legal investigation. The latter may be correct when you consider the village was a place of Anglo-Saxon religious importance, with the consecration of Higbald of Lindisfarne taking place here in AD 780, followed by Eanbald as Archbishop of York in AD 790. The village of 'Socceburg' was also given to the community of St Cuthbert's in AD 990 and may have been a minster of a large estate in the seventh to tenth centuries. The estate became part of the lands of the Conyers family after the Norman Conquest.

All Saints' Church lies in ruins within the grounds of Sockburn Hall and includes a pre-Conquest nave and chancel with alterations dated to the twelfth, thirteenth and fourteenth centuries. The chapel fell into ruin but was restored and reroofed 1900 by W. H. Knowles. The Conyers' chapel contains a superb collection of well-preserved sculptures, including some pre-Conquest cross shafts, hog-backed grave covers, cross heads and later medieval grave covers – some with fourteenth- and fifteenth- century inlaid brasses to members of the Conyers family.

One of the local legends tell of Sockburn as once being the home to a terrible monster called the Sockburn Worm. The beast terrorised the neighbourhood until it was killed by Sir John Conyers, a member of the local noble family and from that day on, tradition dictates that each new Prince-Bishop of Durham be presented with the sword that killed the worm upon entering their new bishopric for the first time at Croft-on-Tees. The ceremony was reported in 1826, though the presentation speech was traditionally made by the Lord of Sockburn.

Thursday afternoon, July 13th, 1826, the Right Rev. William Van Mildert, Lord Bishop of Durham, arrived at Northallerton, the manor, shire, and halmote of which the Bishop of Durham for the time being is lord. On his arrival he was received by Fletcher Rigg, esq., J. S. Walton, esq. (stewards of the manor), and several other gentlemen. After a short stay in the town his lordship, accompanied by his lady and suite, proceeded to Croft where they stopped all night. Next morning the bishop was met on Croft Bridge by Mr. Rayson, agent of the Sockburn estate, who presented his lordship with the traditional sword used in the destruction of the Sockburn Serpent, at the same time uttering the following formula, 'My Lord Bishop, I here present you with the falchion wherewith the champion Conyers slew the worm, dragon, or fiery flying serpent, which destroyed man, woman, and child; in memory of which the king then reigning gave him the manor of

Sockburn, to hold by this tenure, that upon the first entrance of every new bishop into this county, this falchion should be presented.' The bishop then returned the falchion with an appropriate reply.

The Durham historian Hutchinson, writing in the late eighteenth century, was of the opinion that the legend of the Sockburn Worm is a folk tale referring to a long-forgotten Viking attacker who sacked and plundered this part of the Tees Valley. It may well be the Conyers family used this tale to confirm their right to hold the lands here, and so promoted the legend.

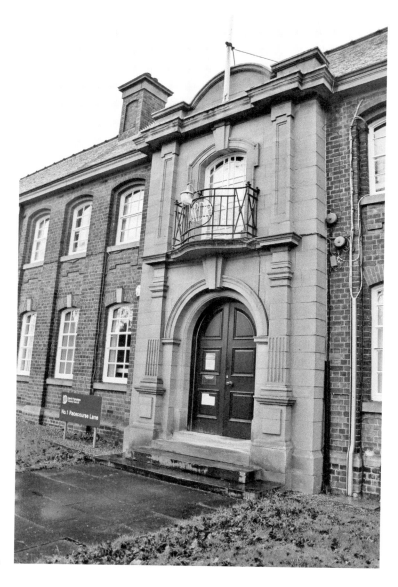

No. 1 Racecourse Lane.

Northallerton Ball of Fire

At around one o'clock on a Sunday morning in 1773, the inhabitants of Northallerton were alarmed by the appearance of a large ball of fire, which passed with incredible velocity from the west to the east. It was reported that 'several houses were greatly agitated, and many doors and windows were forced open.' It was likely a large meteor burning up in the atmosphere, but the locals must have been shocked by the force of this space rock, similar to the one recently reported and videoed in Siberia.

Murder En Route to Northallerton

In 1762, Margaret Middleton, alias Coulson, was executed at Durham for a crime most heinous. She had been employed by a township in Durham to take a pauper child, called Lucy Elliott, alias Curry, to Northallerton where she was to be settled with a foster family. She had received the wages of her journey beforehand but had only taken the child as far

Left: Racecourse Lane.

Below: Old postcard of County Hall.

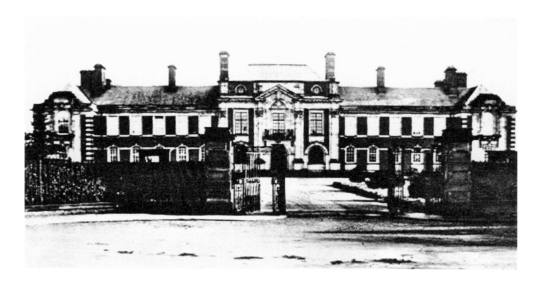

as the River Browney, a tributary of the River Wear, just 2 miles from Durham. According to the courts she had drowned the child in the river on 24 June. She was hanged on Monday 1 August.

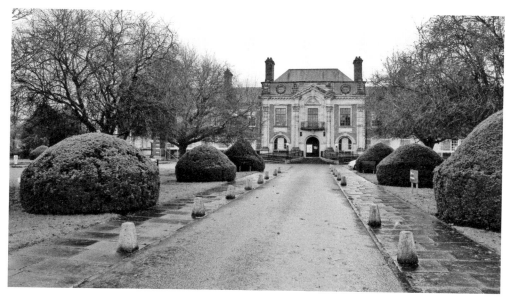

County Hall.

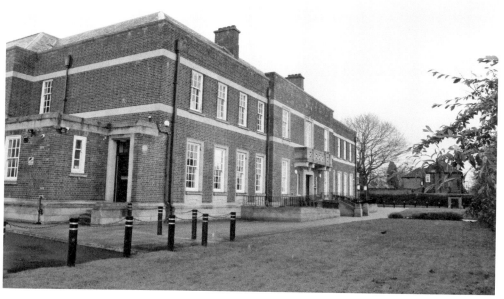

County Court.

The Sad Story of a Visitor to Northallerton

A strange story appears in the annals of Northallerton about a gentleman called Mr Hayes, free porter of Newcastle, who in the winter of 1742 was on a journey to London. Setting off from Newcastle, he arrived at Northallerton on the next evening and obviously stayed overnight to rest and recuperate. After supper he went to bed, apparently in good spirits, but when the servant went to take away the candle, he was shocked to find him with his belly ripped open and several parts cut away. When he was asked the reason for such a rash act, he replied, 'If thine hand offend thee cut it off' and almost immediately died. No explanation for his actions are recorded.

Hambleton Hills Rockslide or Earthquake

In 1755 a remarkable convulsion is recorded as taking place near the ridge of mountains called Black Hamilton (Hambleton Hills), possibly due to an earthquake. The tremors were felt at Northallerton and Thirsk, and the noise was said to resemble the sound of many cannon or a roaring thunder. Revd John Wesley visited Osmotherley shortly afterwards, rode over and made a personal inspection of the place. In his journal, Mr Wesley writes, 'I walked, crept, and climbed round and over a great part of the ruins one part of the solid rock was cleft from the rest in a perpendicular line, and smooth, as if cut with instruments. It is split into many hundred pieces; an oval piece of ground thirty or forty yards in diameter, had been removed, without the least fissure, whole as it was, from beneath the rocks.' The newspaper reported that part of the cliff from which the mass has come is now of so bright a colour that it is plainly visible for miles around. The ridge of rocks called Whiston Cliffs, or Whiston White Mare, are now better known as Whitestone Cliffs near Sutton Bank.

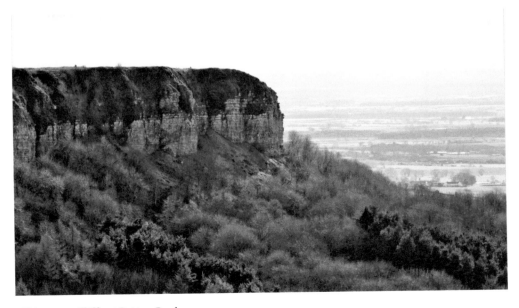

Whitestone Cliffs at Sutton Bank.

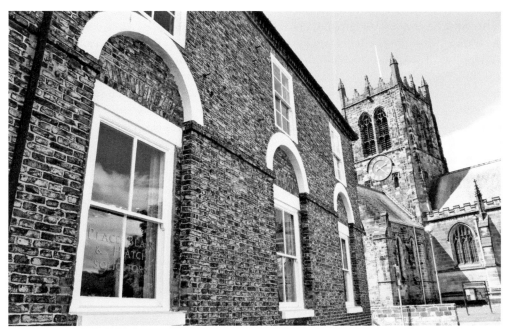

Northallerton Grammar School produced a high number of academics and senior members of the clergy.

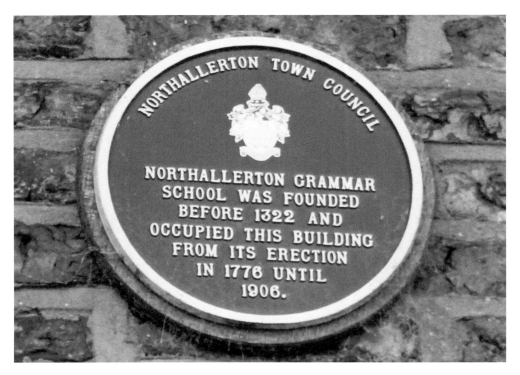

Northallerton Grammar School plaque.

It seems the side of the hill has sheared away and left a huge cliff of white calcareous grit crag exposed – a feature that is still visible from miles around to this day. Apparently, the rumble of ground and rocks continued for a few days until it settled down. The report makes no mention of any injuries or deaths due to this cataclysmic event.

Northallerton Strong Ale

Apparently Northallerton used to be known for a particularly strong ale and though it seems this brew has lost its name to history. According to an old antiquarian called Langdale, the town enjoyed a 'distinguished reputation for the particular manufacture' and he also says with sorrow the brew 'both here and everywhere else, is very much on the decline'. In a poem by Giles Mornington called 'In Praise of Yorkshire Ale', is a couplet:

> Northallerton, in Yorkshire, does excel,
> All England, nay, all Europe, for strong ale,

Langdale also mentions a Mrs Bradley who was most celebrated for making this 'humming stuff', as he refers to it.

Balloon Rides

In the late 1700s there was an experience few would expect to have occurred: mentioned in the *York Chronicle* of 1783 is a 'Ballooning Shuttle Service', where gentlemen could travel

Barkers Arcade.

between Northallerton, Stokesley, Guisborough and Whitby, for the purpose of excitement, drinking and dining. This notice appeared in the *York Chronicle* of 10 January 1783:

> Whereas the air balloon has been found to be of such singular advantage in France, in conveying people in an easy and expeditious manner from place to place: this is to give notice, that for the accommodation of people in the neighbourhood of Whitby, a large one is now completed there, with every advantage equal to those in France, which will be found the best and cheapest conveyance from thence to meet the fly, at Northallerton; as the innkeepers have of late been so extravagant in their charges. It will set off every morning at eight o'clock, from the Robin Hood in Northallerton, and be at Stokesley about half-past eight, at Guisborough about nine, at Whitby to dine, and will return to Northallerton the same evening.

It was also noted to be very convenient on Mondays to convey the gentlemen of the law from Stokesley to Guisborough market, and upon its return it was able to bring them home again. It was found it would be very useful if these gentlemen were to get drunk or tire their horses, as there would be ample space in the balloon carriage for putting any paperwork, cases or bottles. The balloons must have become a familiar sight across the skies of North Yorkshire between Northallerton and Whitby.

Poisoned in Dreams

In May 1786, the forty-six-year-old wife of John Ward, local schoolmaster, died at Northallerton after 'losing her senses', according to the records. She had starved herself to

Betty's Tea Room, known throughout the world.

death 'in a fit of insanity' due to a fear of being poisoned by her husband. She claimed this terror was created by a dream she had in which she believed her husband had attempted to poison her after being fed three successive meals.

King Alfred the Great Coin

A person when at work ploughing in a field about a mile and a half south of Northallerton, turned up a silver coin. It was ancient and larger than an old shilling, but somewhat thinner, and once cleaned up turned out to be a coin of king Alfred the Great in very good condition for its considerable age.

Gold from Turnips

There is a story about unbelievable luck from the year 1796, when a few turnips were bought by an old lady from George Wood, a Northallerton gardener. When cutting through one of them the knife caught against something hard in the middle of the turnip, which proved to be a gold wedding ring.

 The gardener's wife was called and asked if she had ever lost or knew of anyone who had lost a gold ring in the garden where the turnips were grown. She replied that one day, around fourteen years ago, she had been weeding the garden and had lost her wedding ring from her finger. She gave a description of the ring and the old lady who purchased the turnips was sure this was the same ring she had lost. Handing it back the woman recognised it immediately and was overjoyed to have recovered the ring she had lost so long ago, and only a year or so after she had married her husband George Wood. It seems the turnip must have grown through the ring and eventually enclosed it, and only upon its cutting did it reveal its prize.

Skeletons Found in the River Wiske

During some excavations being carried out on the River Wiske in 1822, the workmen uncovered several skeletons of men below the bed of the river and were suspected of having lain there since the battle of Flodden Field in Northumberland. William Conyers (1468–1524) of Hornby Castle, Lord of Lazenby and Hutton Bonville (just adjoining the river where the skeletons were found) is supposed to have had a large army encamped on the neighbouring plains where he was joined by Lord Stanley from Lancashire, with his retainers, before marching into Scotland. The Battle of Flodden Field was fought in September, just south of the River Tweed, between the forces of James IV of Scotland and Henry VIII. The battle was a great victory for the English, and the king of Scotland along with many of his nobles were killed. The skeletons found at the River Wiske are thought to be soldiers who fell ill and died before the march north.

Blood Money

Towards the early part of this century, a singular custom prevailed in the town and neighbourhood of Northallerton. In the springtime nearly all the robust male adults, and occasionally females, visited a surgeon to be bled – a process that they considered essentially conduced to vigorous health. For this operation a fee of 1s was charged and, it would seem, cheerfully paid. It was doubtless a matter for deep regret to the medical

profession when the superstition died out, as this 'blood money' periodically amounted to a considerable sum. Indeed, there would have been strenuous efforts put forth to keep the custom alive had compulsory vaccination not come into force, and so averted the pecuniary loss thus sustained.

Above: Ornate doorway.

Right: Newspaper headlines following the Sex Pistols appearance on the *Today Show* TV programme.

THE FILTH AND THE FURY!

7. Did They Play in Northallerton?

They may not be everyone's cup of tea but on Wednesday 19 May 1976, just a few months before their notorious appearance on the *Today Show* with Bill Grundy, the Sex Pistols performed at Sayers nightclub on Elder Road, where Club Amadeus is (at the time of writing). They became infamous after being goaded to swear on national television by the presenter soon to fade into obscurity – Bill Grundy. The front pages of the newspapers were reflecting the moral outrage with aghast headlines including the *Daily Mirror*'s 'Filth and Fury' classic and much used in later band publicity. This story broke punk to the masses and, as the establishment feared, the more rebellious kids embraced it.

The Sex Pistols line up consisted of Johnny Rotten, Steve Jones, Glen Matlock and Paul Cook; it would be another year before the notorious Sid Vicious joined the group. They were supporting a headline act called Doctors of Madness who are described as a 'protopunk band' from South London led by frontman Richard Strange, known as Kid Strange. The Doctors of Madness had limited commercial success even though they produced three albums on the Polydor record label, but the Sex Pistols spiralled to fame and sold millions of records.

Punk bands at the time were struggling to find venues to play and the Sex Pistols had not played much out of London at this stage until they took on Northallerton, then The Penthouse in Scarborough, followed by Middlesbrough Town Hall and a venue in Lincoln. These small venues were unlikely places to host the next big musical trend to hit Britain. Prior to the Sex Pistols, the Northallerton venue had hosted acts of yesteryear such as Wayne Fontana and the Mindbenders and The Searchers.

The DJ at Sayers was Brian Simpson, who is reported as remembering people leaving the club when the Sex Pistols began playing. He had commented, 'Northallerton was suddenly at the forefront of punk rock but we had no idea that we were. It was about two weeks later when I saw their picture in one of the music papers that I realised I'd seen them play.'

Part of the entourage was Cindy Stern, who attended these northern gigs with his then girlfriend Pauline Murray (who later became the lead singer of County Durham band Penetration) and his camera. He had been a regular in Malcolm McLaren and Vivienne Westwood's shop on the Kings Road and was told the Pistols were playing a short northern tour. Stern described: 'The Northallerton venue was tiny but as there were just 10 people there, that was hardly an issue, and of the 10, eight of them were just there for a drink!' His photographs captured some history of when punk was still a few months from the headline news it was to become, but the undercurrent of menace and violence at these early gigs as drunken punters reacted in a hostile manner to the Sex Pistols' confrontational stage presence was apparently there to see.

The date 19 May 1976 goes down in history as the day Northallerton was at the forefront of musical change in the country, and soon the world. The movement brought many great bands to prominence including Blondie, The Police and The Clash. It also dragged other great bands along with it like The Stranglers, Dr Feelgood, Elvis Costello and Ian Dury to name but a few. With a certain sense of irony, I noticed the 1823 *Gazetteer* mentions a William Grundy as the landlord of the White Horse in Northallerton – could this be a relation?

DID YOU KNOW?
The Sex Pistols followed their Northallerton gig with one at the Penthouse in Scarborough on 20 May, and the Middlesbrough Town Hall the night after.

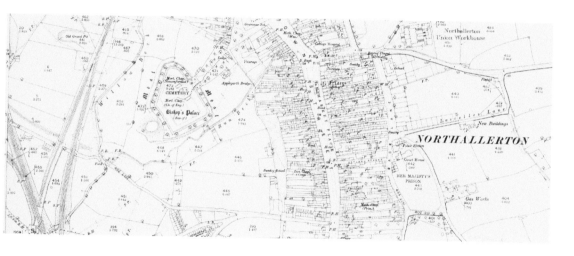

Above: Map of the town.

Right: The Fleece plaque.

Amazing tomb in Northallerton Cemetery.

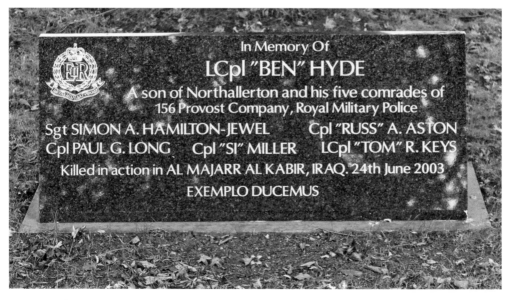

A memorial to a more recent sad loss to the town during the conflict in Iraq.